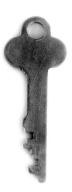

Copyediting: Louisa Elderton and Blair Smith
Photo Editor: Alison Morley

Graphic Design: Bonnie Briant
Typeface: Garamond 3

Project Management: Claire Cichy, Hatje Cantz
Production: Julia Günther, Hatje Cantz
Reproductions: Jan Scheffler, prints professional, Berlin

Printing: Offsetdruckerei Karl Grammlich GmbH, Pliezhausen
Paper: PhoenixMotion Xantur, 150 g/m²
Binding: Josef Spinner Großbuchbinderei GmbH, Ottersweier

Published by
Hatje Cantz Verlag GmbH
Mommsenstrasse 27
10629 Berlin
Germany
Tel. +49 30 3464678-00
Fax +49 30 3464678-29
www.hatjecantz.com
A Ganske Publishing Group company

Hatje Cantz books are available internationally at selected bookstores.
For more information about our distribution partners,
please visit our website at www.hatjecantz.com.

ISBN 978-3-7757-4248-1
Printed in Germany

The Family Imprint

A Daughter's Portrait of Love and Loss

Photographs by

Nancy Borowick

Introduction by James Estrin

Mom and Dad:

Even in death, you remind me to be grateful for the time I have
left on this magnificent planet. This book is for so many.
It's for you, our family, and for the multitude of lives you've
already touched by allowing me to tell our story.

— Nancy

Introduction

by James Estrin

The power of Nancy Borowick's seminal work on her family's struggle with cancer is that it is not about cancer. It is about the tender and passionate love story of her parents, both of whom happened to have had stage-four malignancies at the same time. It is an epic, sweeping tale that explores the journey of a family embracing life in the face of death.

Nancy has spent much of her life in cancer's shadow. Three of her grandparents died of it. Her mother, Laurel, was first diagnosed with breast cancer in 1997—when Nancy was just twelve—and fought recurrences in 2009 and 2011, before finally succumbing to it in 2014. Her father, Howie, was diagnosed with stage-four pancreatic cancer in 2012, and died the following year.

Nancy began photographing her mother's struggle in 2009 as her final project for the "Documentary Photography and Photojournalism" program at the International Center of Photography (ICP). Because both Nancy and her mother wanted to spend time together, Laurel agreed to be photographed, but did not want to be portrayed as the stereotypical brave cancer survivor. She did not feel heroic; she was angry that the disease had returned. As ICP mounted its exhibition of final year projects, Laurel's cancer went into remission and Nancy thought and prayed that the project had come to a close.

However, Laurel's cancer returned in 2011. In 2012, when Howie received a terminal diagnosis, he asked his daughter to begin photographing him.

Howie was a gregarious, highly successful personal injury lawyer who always wanted to have the last word. Laurel was also a lawyer, but decided to stay at home to raise her family. She was quieter than her husband, optimistic and invariably kept lists of things to do. Together, they focused on taking advantage of the time they had left, but did not avoid talking about death with Nancy and her siblings, Jessica and Matt.

Looking at these photographs we become immersed in the Borowick's world, and when we join them at Nancy's October 2013 wedding to Kyle Grimm, we are in a beautiful country setting with a picture-perfect

bride. What we do not see is Nancy climbing a tree only a few hours earlier to position a remote camera so that she can unobtrusively take a photograph of her parents walking her down the aisle. Later that day, Nancy photographed her parents in chairs as friends and family lifted them and danced in celebration.

Nancy's images bring us into her family in a way that feels unmediated. They become our friends and our family. Though Nancy does not shy away from the darker and more difficult moments, the photos are more about living than dying.

Her camera is more than an instrument; it is a comrade and co-pilot, which allows her to navigate her family's struggle while maintaining some distance.

Two weeks after the wedding, Nancy's photographs were published in *The New York Times*, alongside a story by Michael Winerip, as well as in the newspaper's blog *Lens*, which I co-edit. That same day, Howie took a turn for the worse, and it was less than two months later that he passed away. After thirty-four years of marriage, Laurel spent the final year of her life living without her husband.

The story "Cancer Family" was published by *Lens* in four chapters from December 2013 through March 2016. Over the last two years, I have cried many times while looking at these images—on the Internet, at photography festivals, and listening to talks by Nancy. I have also smiled at Howie and Laurel's shared moments of romance and joy, and have laughed out loud at images that capture their wacky sense of humor in the face of their illnesses.

Cancer is a constant and threatening specter to us all. Everyone knows someone close to them who has been touched by the disease, yet we avoid talking about the topic for fear that it will manifest at its mere mention. The word is spoken only in whispers to indicate that someone is facing a possible death sentence.

Nancy's work is neither quiet nor polite. It shouts at us to seize every moment in which we are alive.

James Estrin is a *New York Times* Staff Photographer and Co-Editor of the *Lens* blog

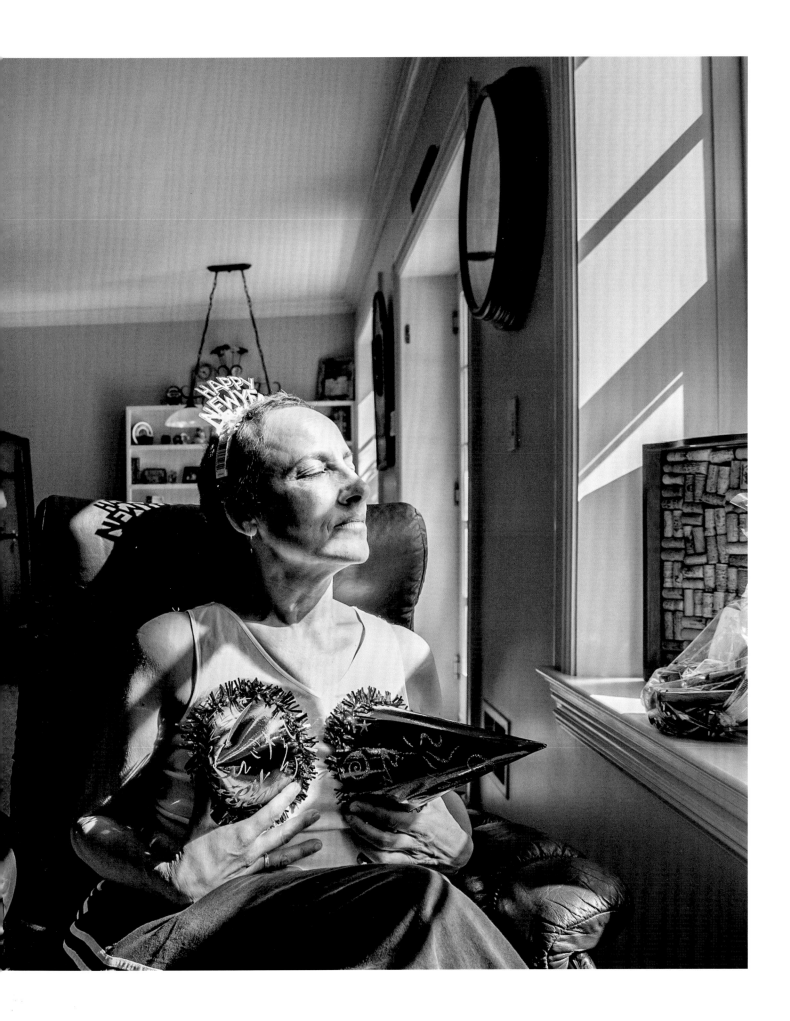

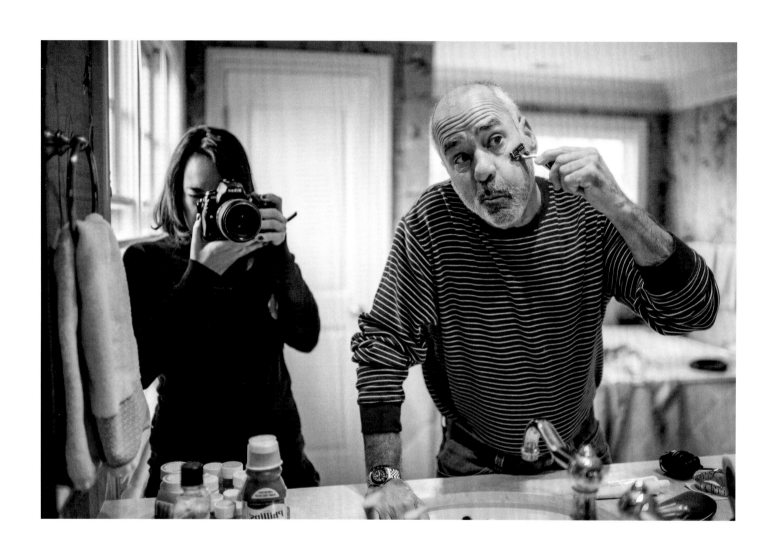

Dear Nancy,
This first entry is for you.
When I agreed to be the subject of
your photo assignment my intention
was to be dependable and available. I knew
I could be helpful, spend quality time with
you and hopefully have the opportunity to do
some nurturing.
What I didn't know then but realize now, is that
I would be the recipient of your help, quality time
and nurturing.
Your photo project has been a catalyst to permit,
legitimize and push me to articulate what I usually
keep buried.
Thank you for helping me to speak from a
place of strength and for providing this opportunity
for me to see the beautiful images
you create with a camera, using
your heart as your guide.
xoxo, Mom

How do you summarize a life in twenty words or less? This was the challenge as my siblings and I struggled to decide what would go on our mother's grave marker. They give you a list of adjectives from which to choose: beloved, devoted, loving, and caring—but in her fifty-nine years she was so much more than these simple predetermined adjectives. She was generous, thoughtful, creative, selfless, curious, and so much more. On birthdays, she would decorate our bedrooms while we slept so that we'd wake up surrounded by an enormous feeling of love and joy. Each time I would come home to visit, there was always a cooked artichoke waiting for me on the stove—my favorite, and she knew it. You can see why this task took us over a year to complete. The hardest thing to face, of course, was the bookend that the grave marker represented; maybe we weren't ready to accept this.

Death may be a universal human experience, but every family experiences it so differently. During the third diagnosis of my mother's breast cancer, my father learned that he had pancreatic cancer. Our family lost its bearings. How could we have both of our parents in simultaneous treatment for stage-four cancer? This reality took some getting used to, but time was not on our side and I think my parents were aware of this.

As their daughter and a photographer, I needed to process what we were going through as a family and, naturally, my camera became that therapeutic tool. Photography allowed me to put this situation into a context through which I could better understand it and my lens allowed me a safe distance from the reality that was unfolding before me—I was losing my parents and there was nothing that I could do about it. In a world that felt like it was fast spiraling downward, my camera became my lifeline and while I had no medical expertise, documenting our story brought a different kind of healing to our pain.

Here is where my parents taught us a lesson in courage: rather than wallowing in their own sadness and grief, they chose to spend their final months living life. Yes, there was chemotherapy, but there were also family dinners,

late-night movies, spontaneous vacations, and fireside chats. I photographed it all. I captured every moment because I needed to hold on to each memory, each frame; I wanted to hold onto the essence of who my parents were and who my family was, before the moments passed and they were gone.

There is no cookie-cutter way of dealing with death. Fortunately, my family never quite fit the mold. A spoon full of Fluff to help the chemo pills go down? Mom certainly thought so. Swapping a traditional Jewish shroud with his favorite Lawrence Taylor Giants Jersey for his burial clothing? Dad demanded it. Along that same rhythm, there I was, camera in hand, photographing both of their funerals. When the time came to bury Dad —and Mom 364 days later—almost everything had been taken care of because my parents wanted to talk about their deaths, a conversation many actively try to avoid. We knew which plots they wanted; we knew their medical requests for their final days; heck, we even knew what my father wanted to be said at his funeral, because he wrote his own eulogy. Mom spent her final weeks banking blood at the local hospital, to be used for future research after she was gone, and also made a request for a sustainable wood casket so that in death she would still be doing her best for the Earth. Even though I only had twenty-eight years with Dad and twenty-nine with Mom, I feel like I won the lottery.

While these last few years have been the most difficult of my life, they have also been beautiful and filled with love, life, and lessons I will always hold on to. The Borowick way to share our many lessons would be to write them as a list, written on a colorful Post-It note. This book is my note, my list, my love letter to my parents.

I have my photographs, my records, which hold tight the moments of joy and pain, together telling the story of what it truly means to live. — Nancy

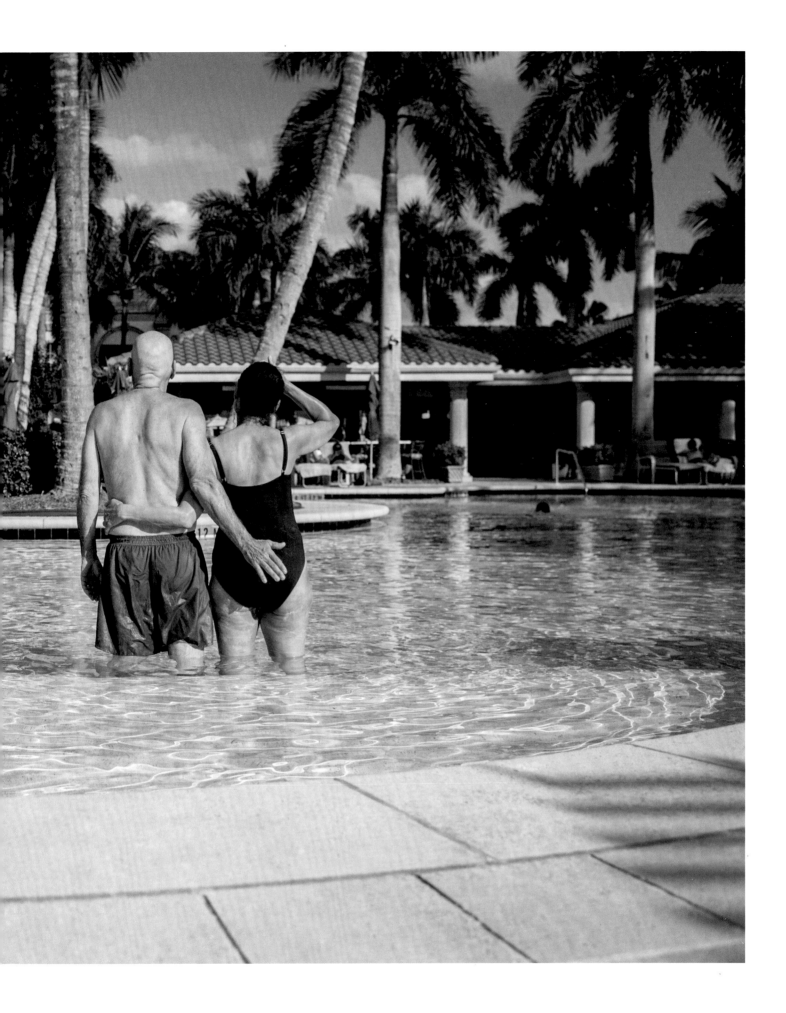

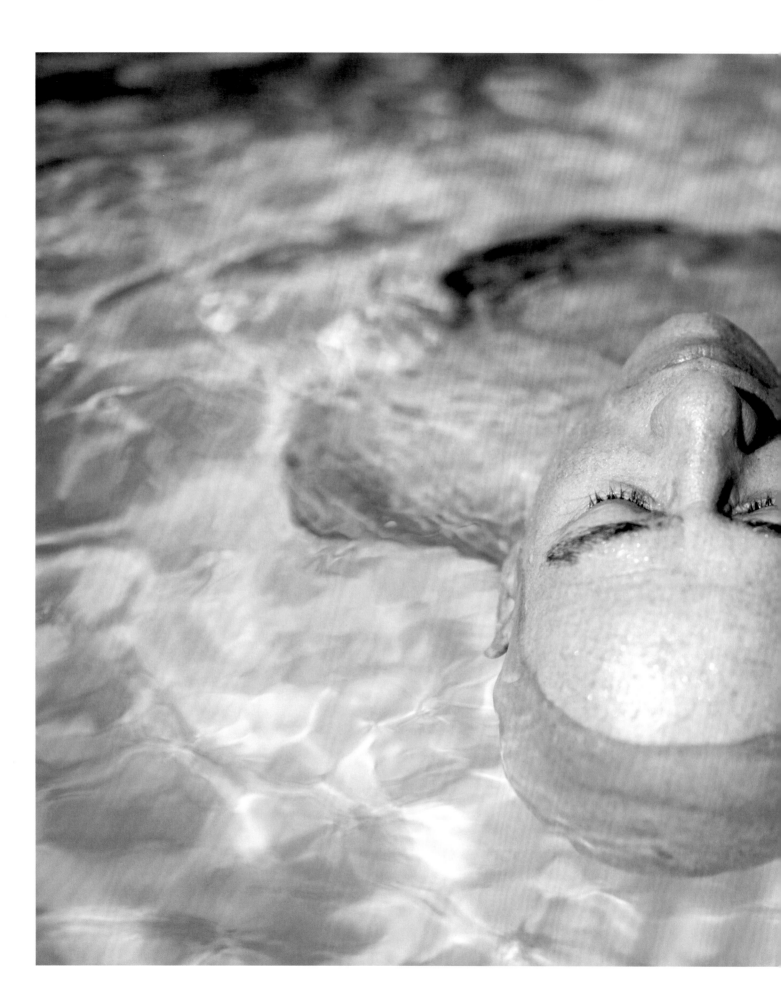

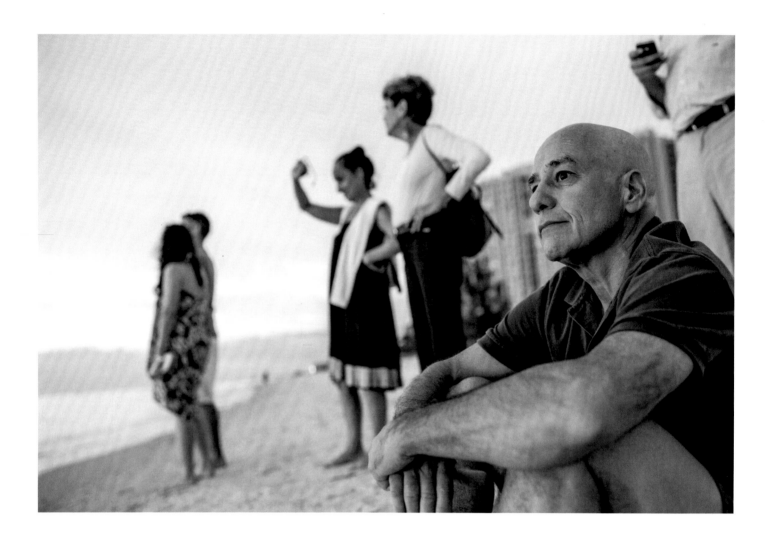

Well, marrying Mom was easy. I'm a romantic and I had already half-assed proposed to other people.
But they were mistakes and I'm so happy that these people saw them as mistakes.
So I met Mom and I immediately thought she was going to be part of my plans for at least the summer.
We started to go out and she was just great. Our first date was perfect. She let me talk for seven
hours about myself, never interrupted, seemed interested, and … she's just … she was beautiful.
She was the prettiest girl in school. She was a great listener, she was really smart, she was a great dancer,
and a great singer. And she loved me. She loved my family. Within three months, we were going
away for weekends. Within four months we were looking for a ring. — Dad

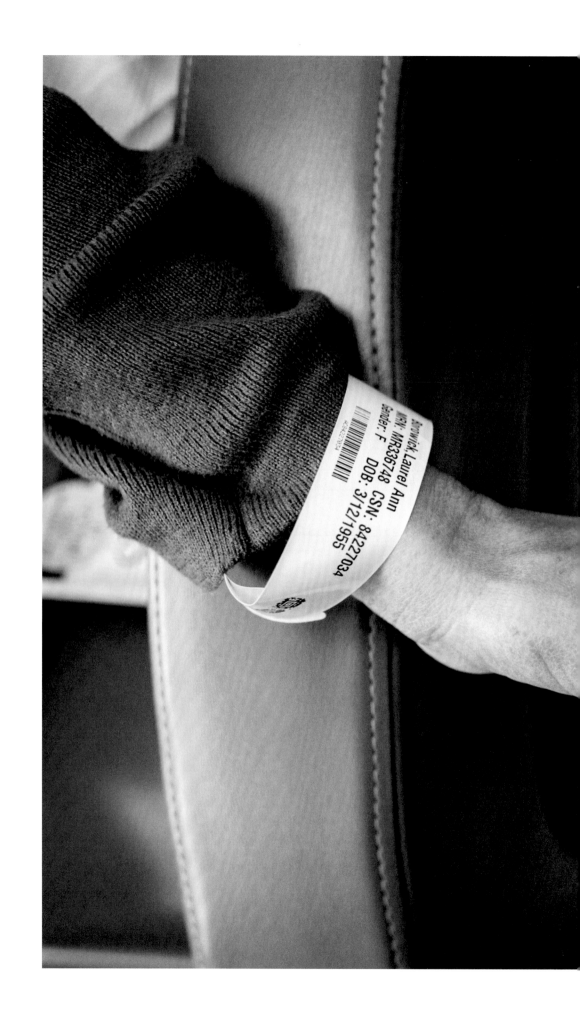

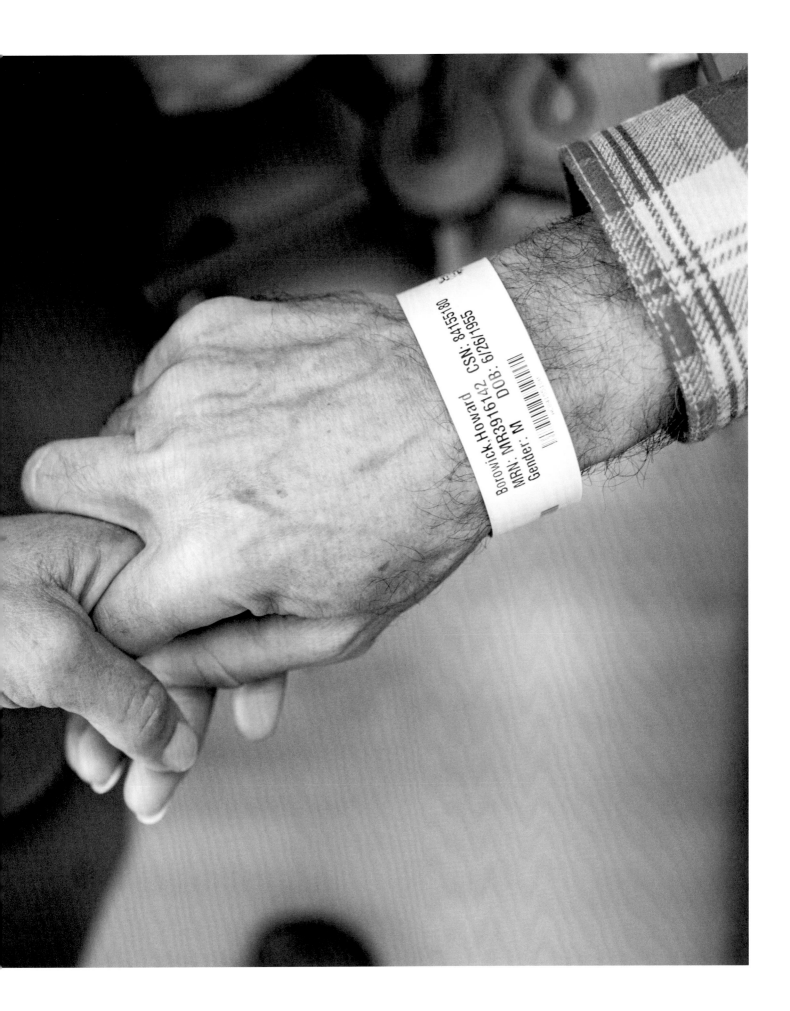

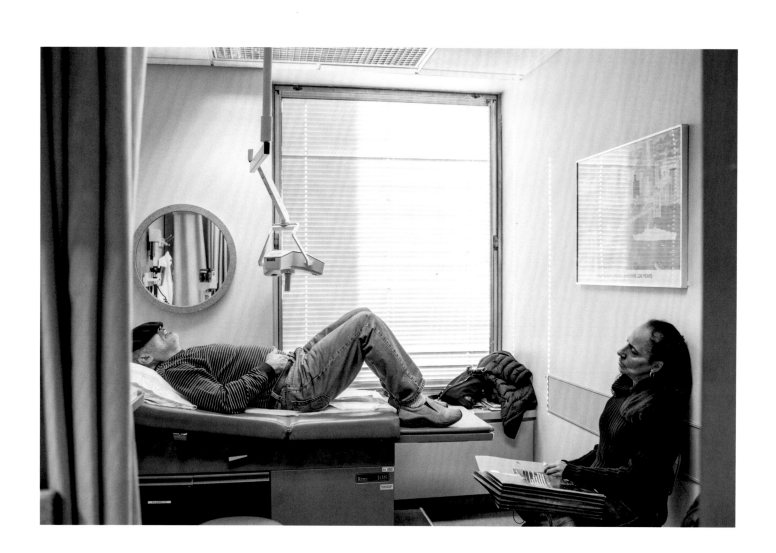

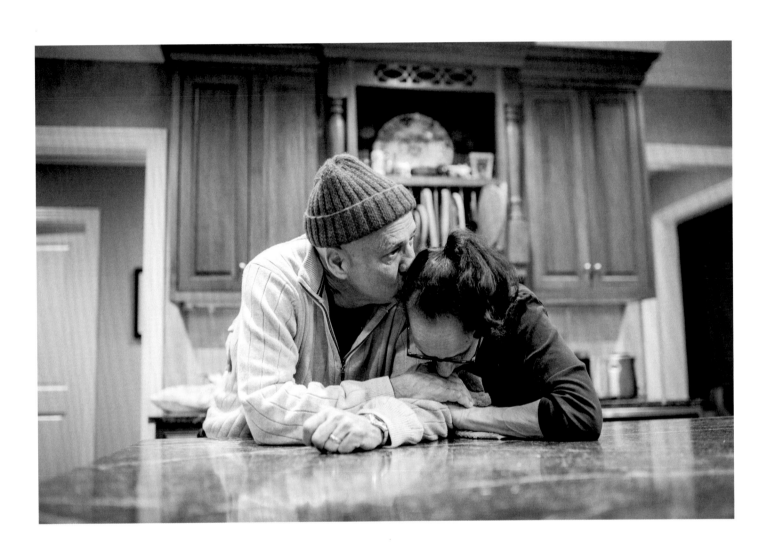

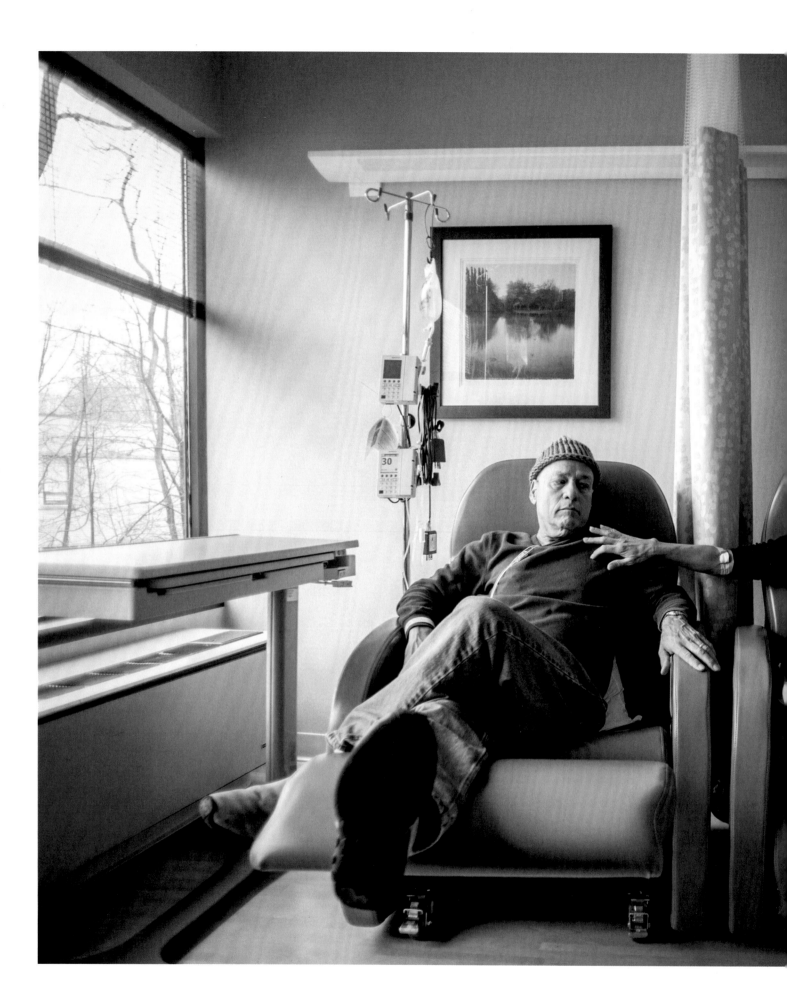

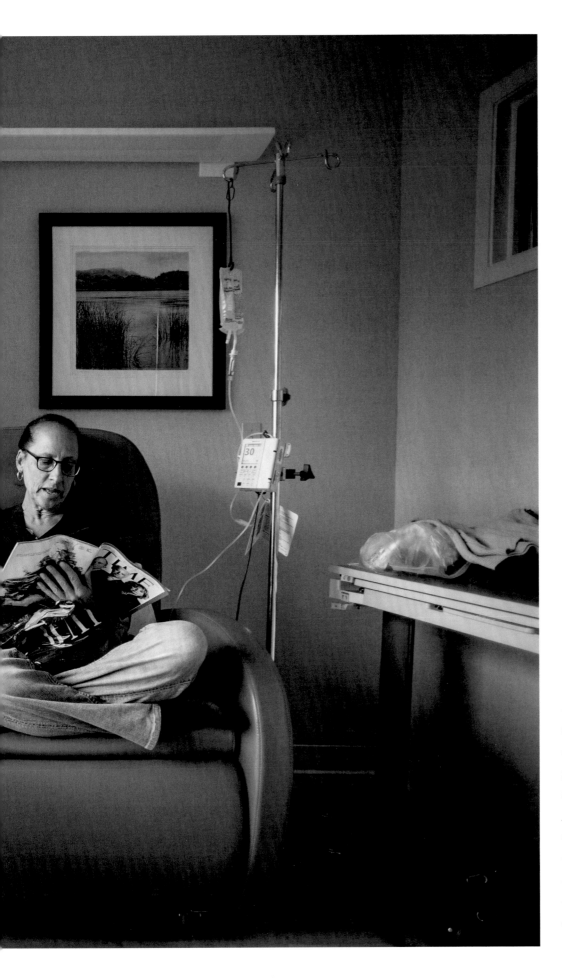

*Dad called these "his and hers
chairs." He would sit beside Mom,
his partner and wife of thirty-four
years, as they got their weekly
chemotherapy treatments. He had
just been diagnosed with pancreatic
cancer and she was in treatment for
breast cancer for the third time
in her life. For him it was new and
unknown, and for her it was business
as usual, another appointment
on her calendar. — Nancy*

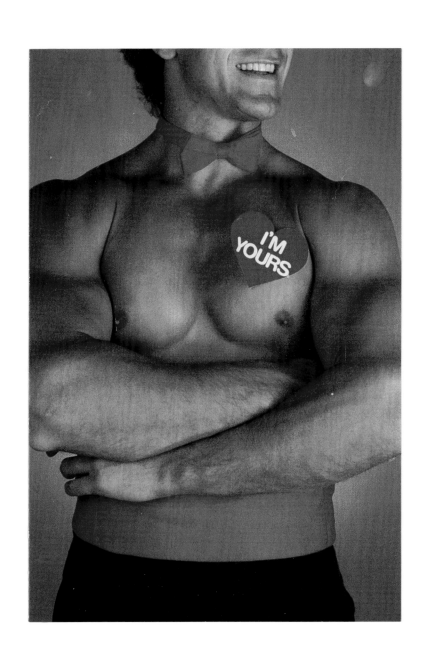

A good man,
A good father,
A good friend

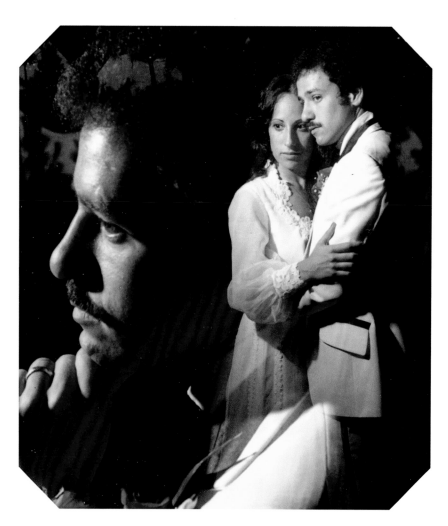
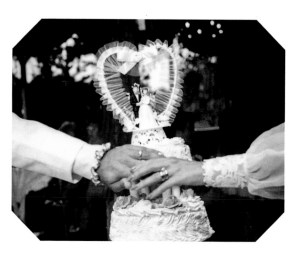
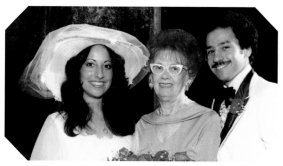
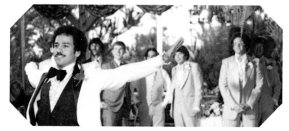
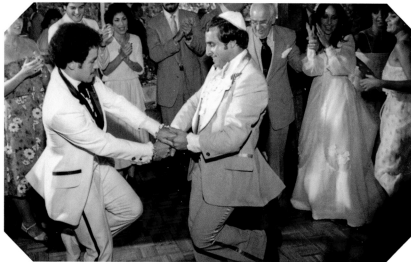
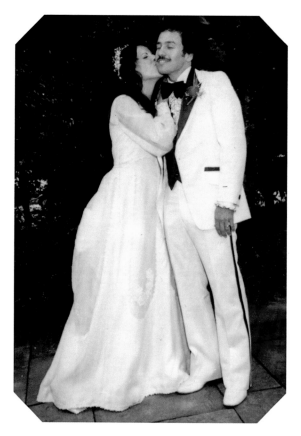
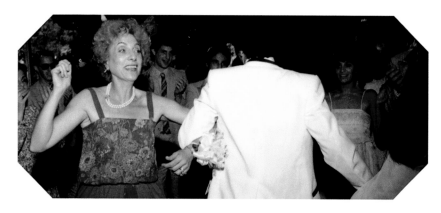

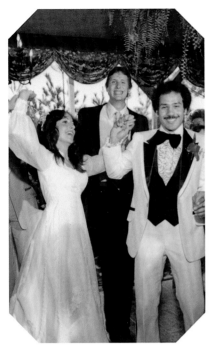
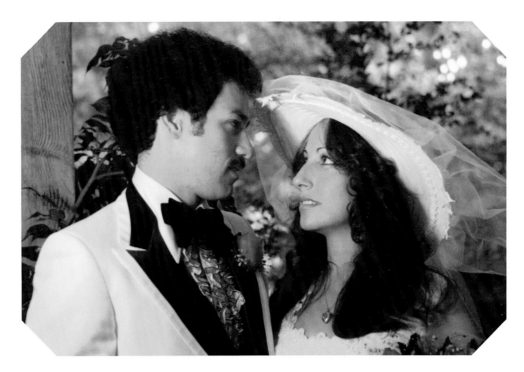
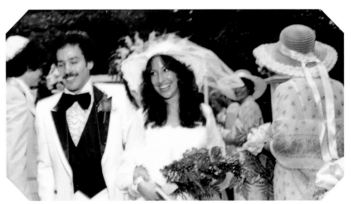
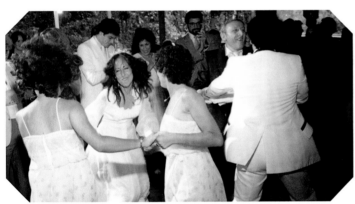
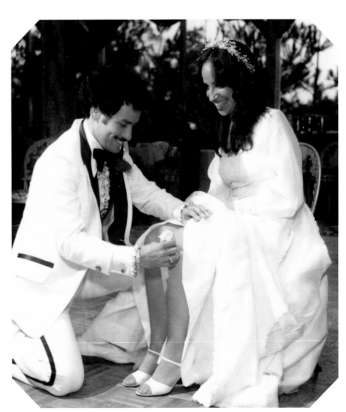
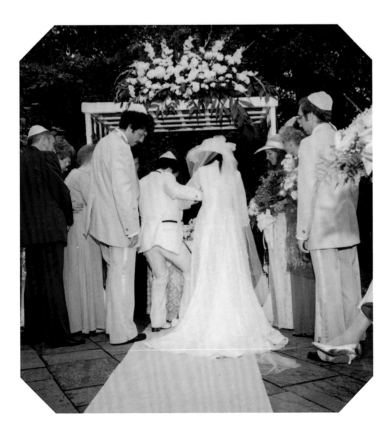

It felt strange because I had no hair and no breast. I felt kind of weird, kind of
masculine. I didn't feel like I was a feminine being. I didn't feel like
I was a sexual being. I kind of felt like an "it." I looked in the mirror and I was just
this funny-looking person. I didn't look like a man or a woman.
I just looked like an "it." Dad gave me the strength to come out the other
side and to get through it. — Mom

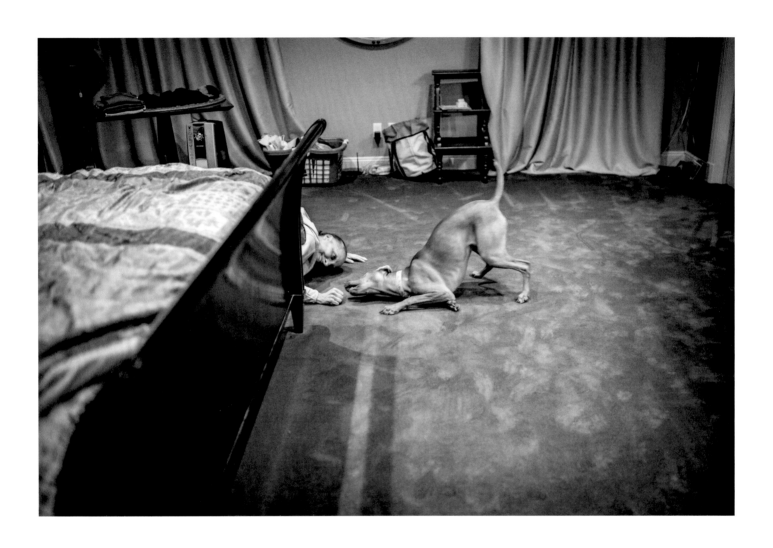

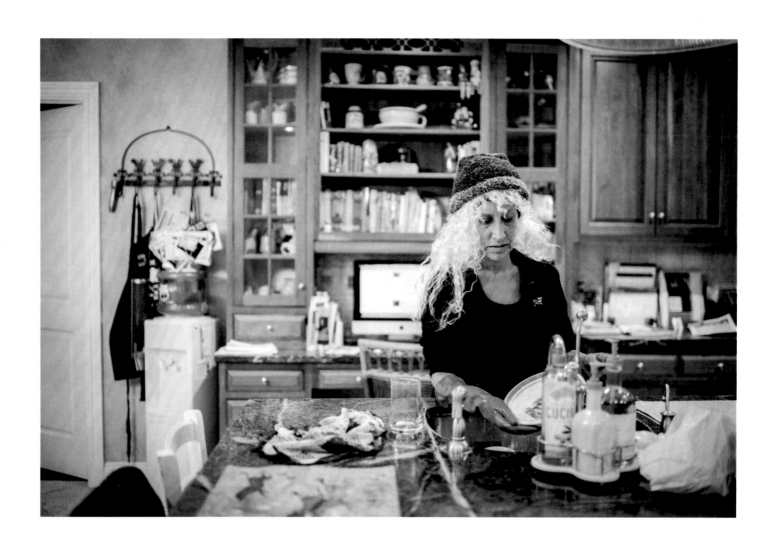

With every new diagnosis of cancer and new round of chemotherapy, Mom would lose her
hair and, in turn, she would buy a new wig. However, she never held onto her
wigs after she was cancer-free because her hair would grow back, so she would donate them.
Humor got us through these tough moments. — *Nancy*

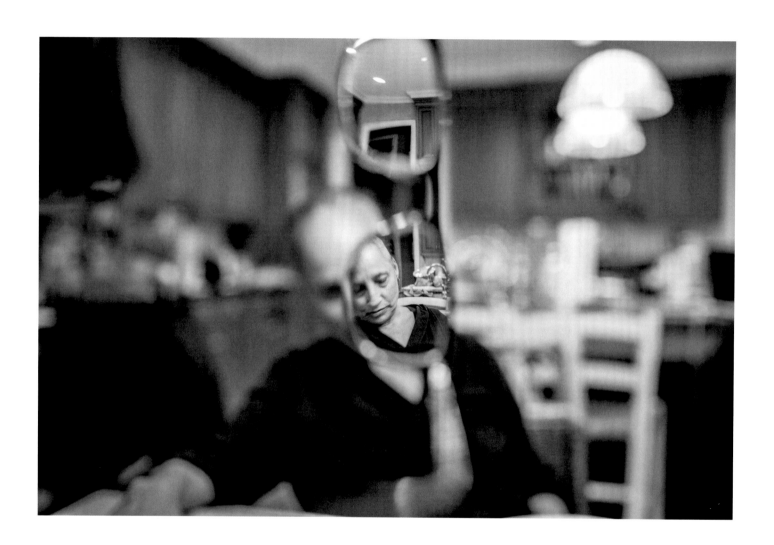

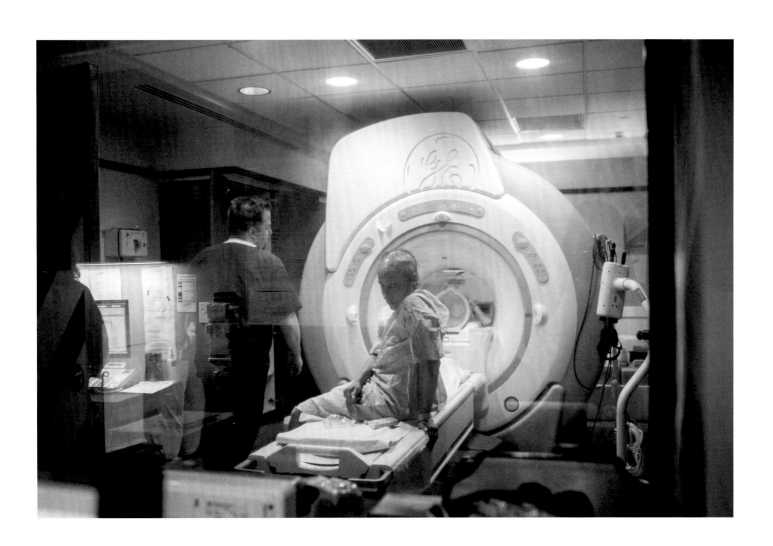

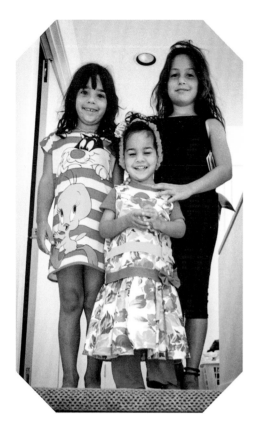
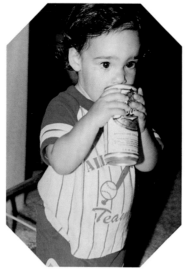
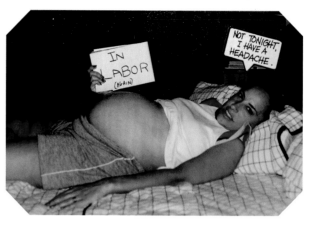

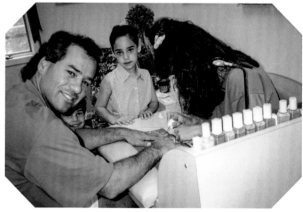
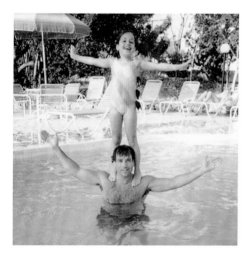
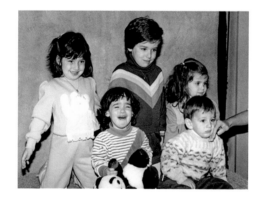
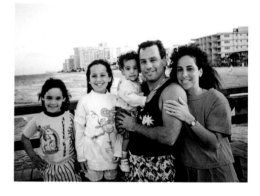
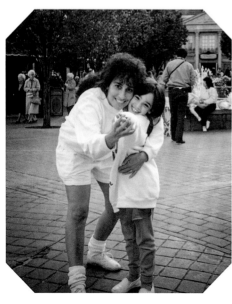

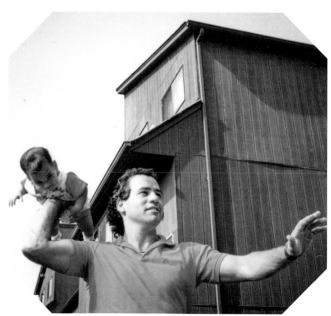

Parenting Advice

(~~to give them credit~~)
~~Be aware~~ ~~that~~ kids are a lot smarter, intuitive

Patience communication
Love trust
Kindness

If some "value" is impt. to you & you want to share
it w/your son/daughter, ~~don't~~ talk about it/preach it,
live ~~life~~. I think kids learn so much by <u>watching</u> their
parents (vs. listening)

(~~&~~ I've definitely made mistakes in this area.

Having a child, changes priorities, or at least it includes ~~thinking~~
~~about~~ a "rebalancing". Our 1ˢᵗ New Years after Jessie
was born. You woke up Dec. 31ˢᵗ, 1982 with a fever
& despite drugs it rose during the day. We had parties &
a mature baby-sitter, but I chose to stay home ~~with~~
~~her because~~ because ~~of~~ my priorities had changed.

~~My child was more impt than my social life?~~

Read, ~~to~~ ~~talk~~ ~~sing~~ ~~babies~~ communicate with yur babies, & kids—
& ~~solve~~ with violence — ~~If you~~ ~~that~~ full anger

There is no excuse to hit a child (or an animal) if
you feel that much anger or frustration — walk away

Dad was losing weight fast and needed to dramatically increase his caloric intake. Doctor's orders were to eat anything and everything, so our family went on what we called, a "calorie-dense diet." While dad was the one who needed to gain the weight, we were a family, meaning that we were in this together (and it didn't take much convincing). If he was going to gain weight, we would help and gain weight right alongside him. Fried chicken, take-out Chinese food, and pizza were some of our go-tos. — Nancy

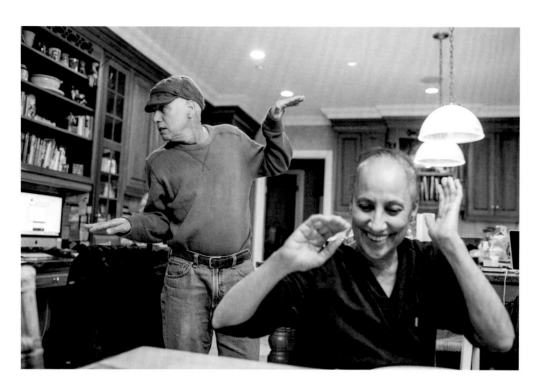

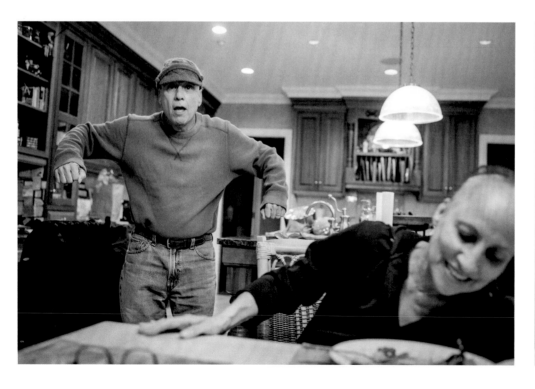

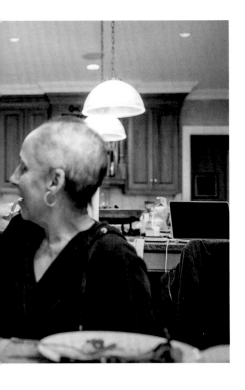
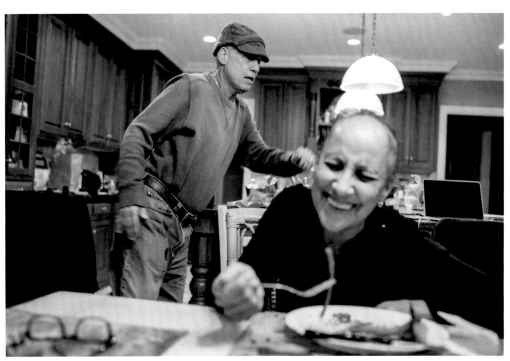
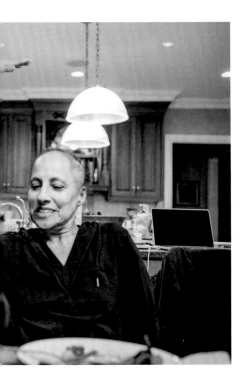
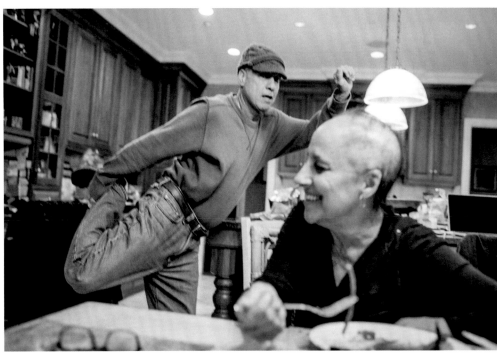

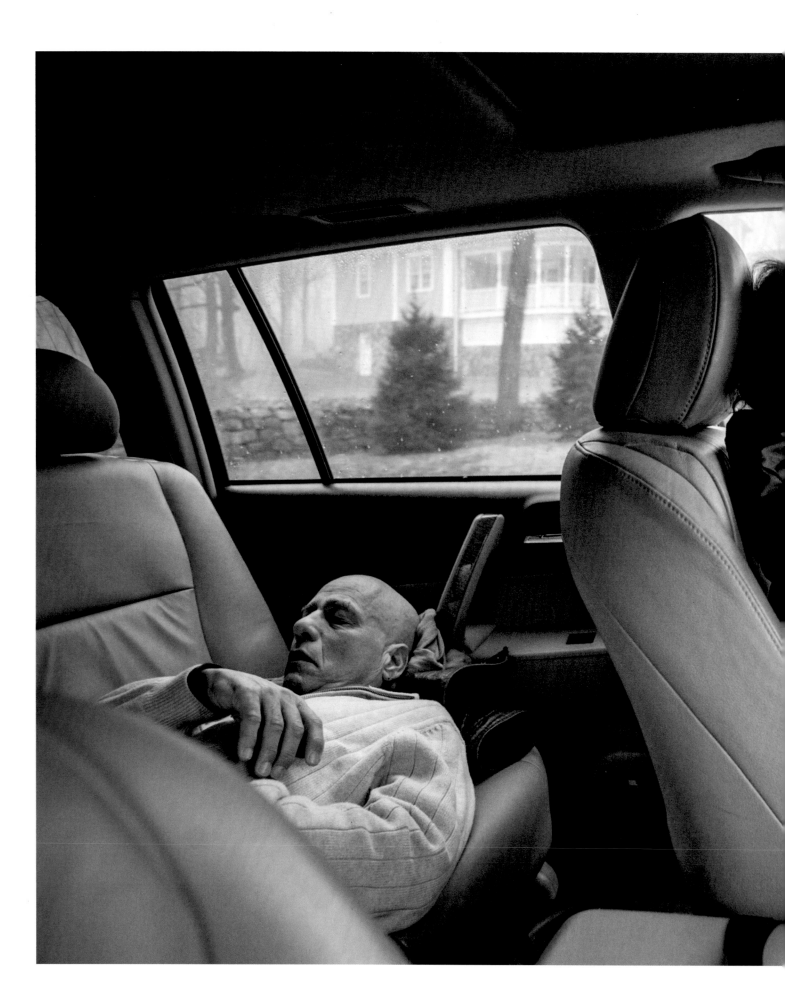

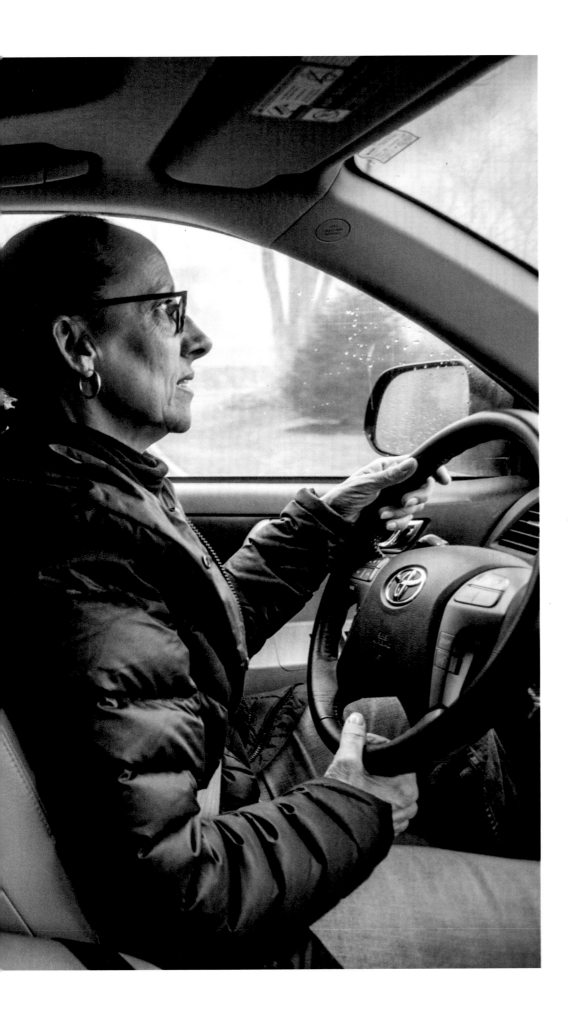

My philosophy on life is that it's a gift, and any amount of years is a gift.
Nobody promised me longevity. Nobody promised me success.
Nobody promised me love. Nobody promised me healthy kids.
Nobody promised me good friends. Nobody promised me a great career,
and yet, I've had all those. So, I'm way ahead in the
balloting and accounting. I have no regrets because without
any guarantees, I've been able to achieve those things and I've been
blessed with them for a long, long time.

Obviously my father would have given his right arm and leg to
reach thirty. I can only imagine him laying in his deathbed at twenty-six,
thinking about how he's got two little babies who are never
going to see their dad as they grow up, and wife of twenty-five, who's
going to be widowed. When I think of those things ...
he's a person I feel bad for. He's a person I feel was cheated.
Although, even there: he found love, he had children, and he found
success, so you have to look at balance. You have no guarantees,
and what you get in your life is a bonus. — Dad

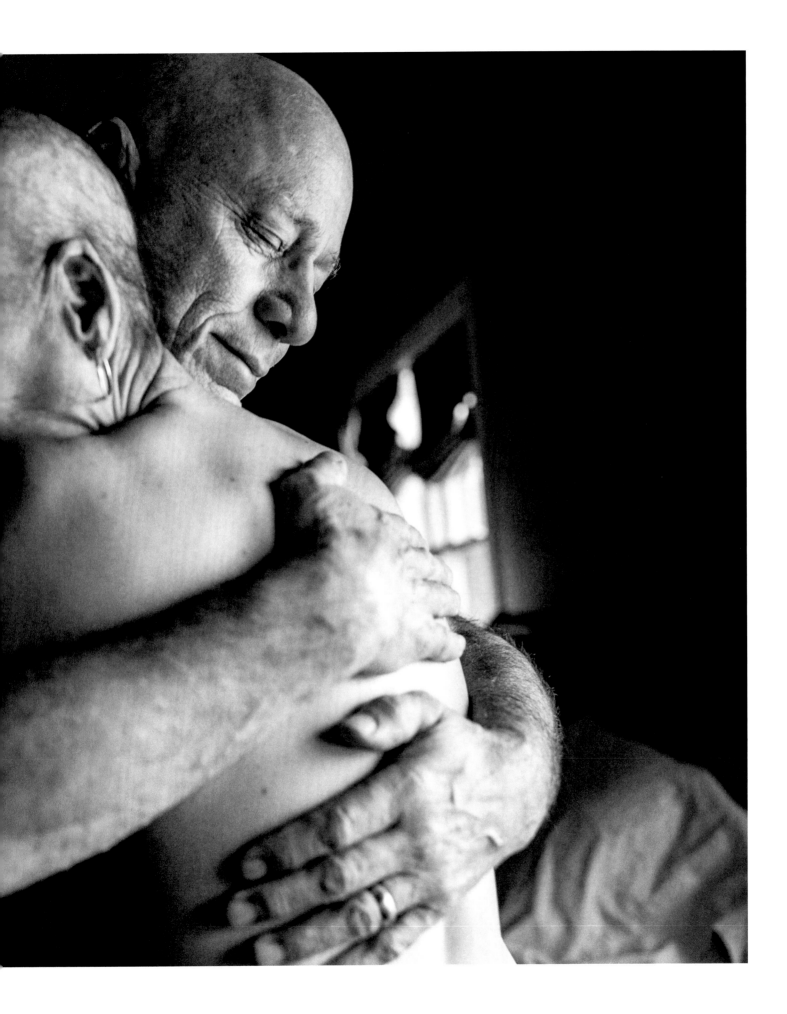

When the doctor calls to give you news about your scan results, who takes such an important
phone call in the bathroom? My parents did. As I waited for reactions and information,
I saw Mom beginning to wipe tears from her eyes. It turned out to be good news for both of them
—the tumors were shrinking. But what if one had good news and the other had bad news?
Do you celebrate for yourself and mourn for the other? — Nancy

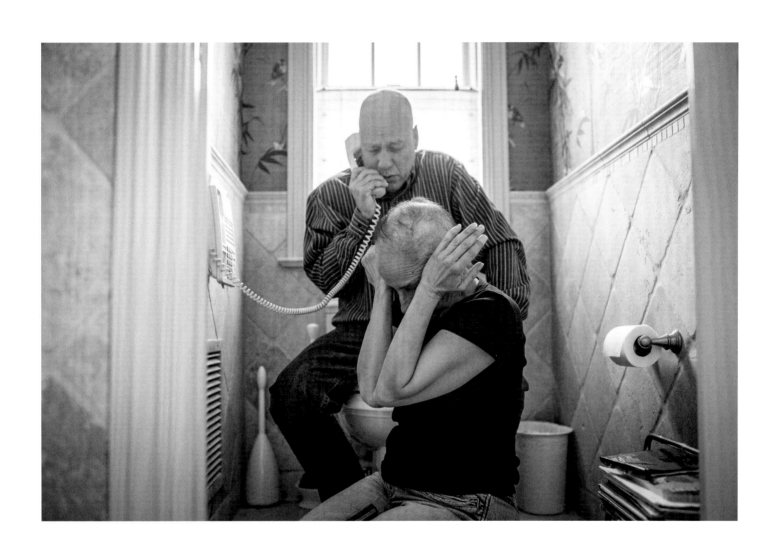

Mama's Meatballs -

2 lb. g meat
2 eggs
3½ eggshells g water in bowl.
a little bit g salt
a little bit g garlic
a little bit g onion powder.
mix in bowl.
handful g matzoh meal.

Put 2 little cans g tomato sauce.
2 cans g water in ~~pot~~ bowl.
make meatballs - put on plate
lower boiling light & cook for
1½ hrs.

add water if necess.

Need - tom sauce (2)
 matzoh meal

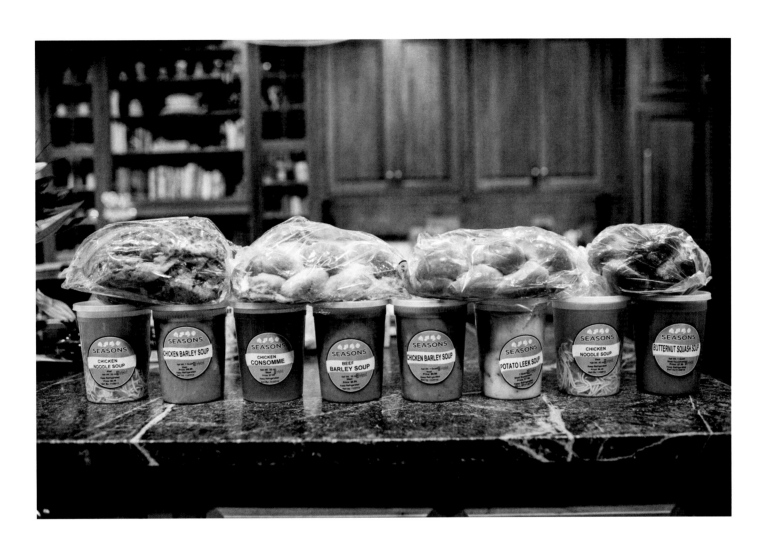

When I asked my parents' oncologist when I should plan my wedding,
his answer was short—as soon as possible. Maybe the question
I was really asking him was: "How much time do we have?"
It was difficult to bounce back and forth between hope and despair,
and I knew he couldn't give me a clear timeframe. — Nancy

THESE KIDS ARE GETTING MARRIED!
NANCY BOROWICK & KYLE GRIMM

OCTOBER 5, 2013 · LIBERTY VIEW FARM · HIGHLAND, NEW YORK
FOR MORE INFORMATION PLEASE VISIT NANCYANDKYLE.COM

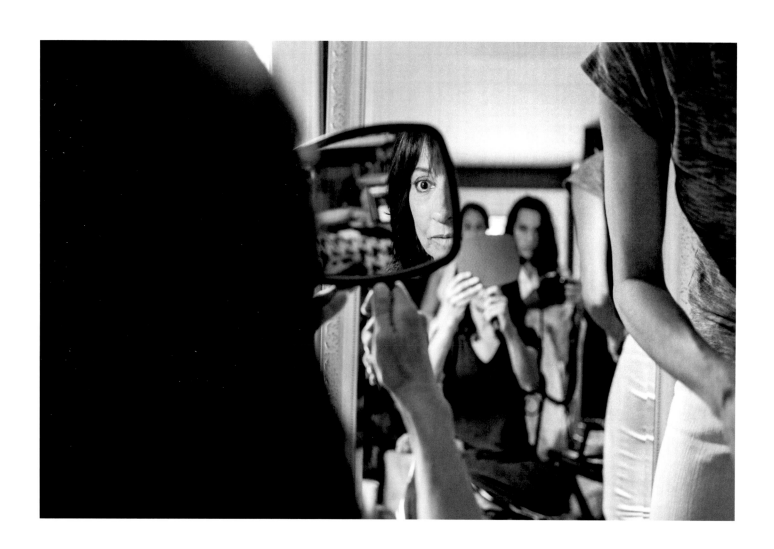

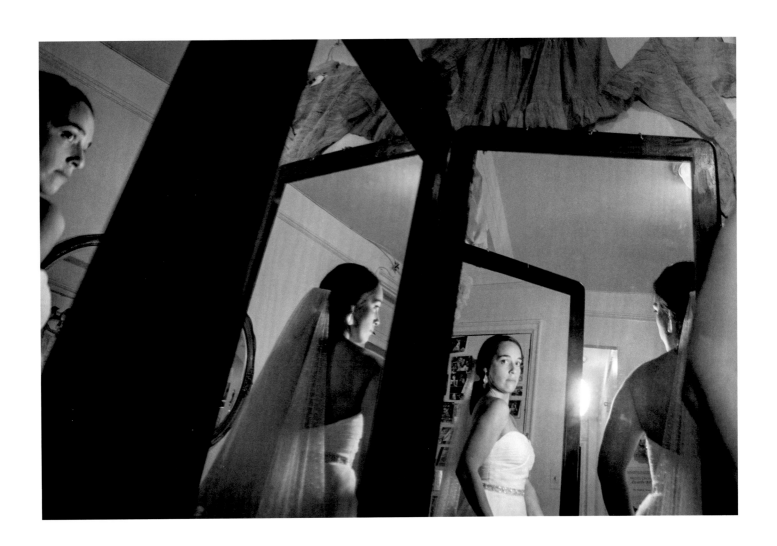

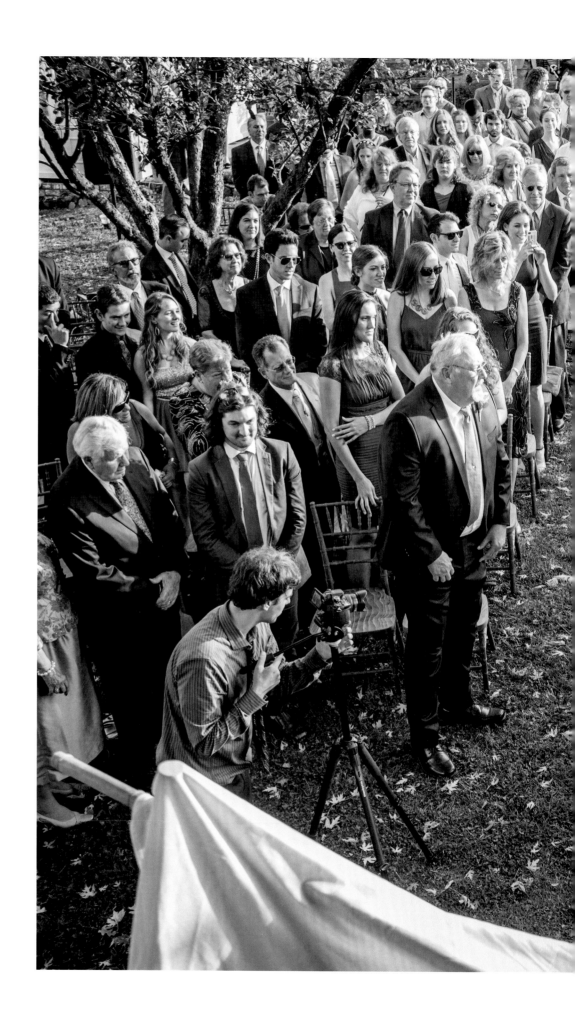

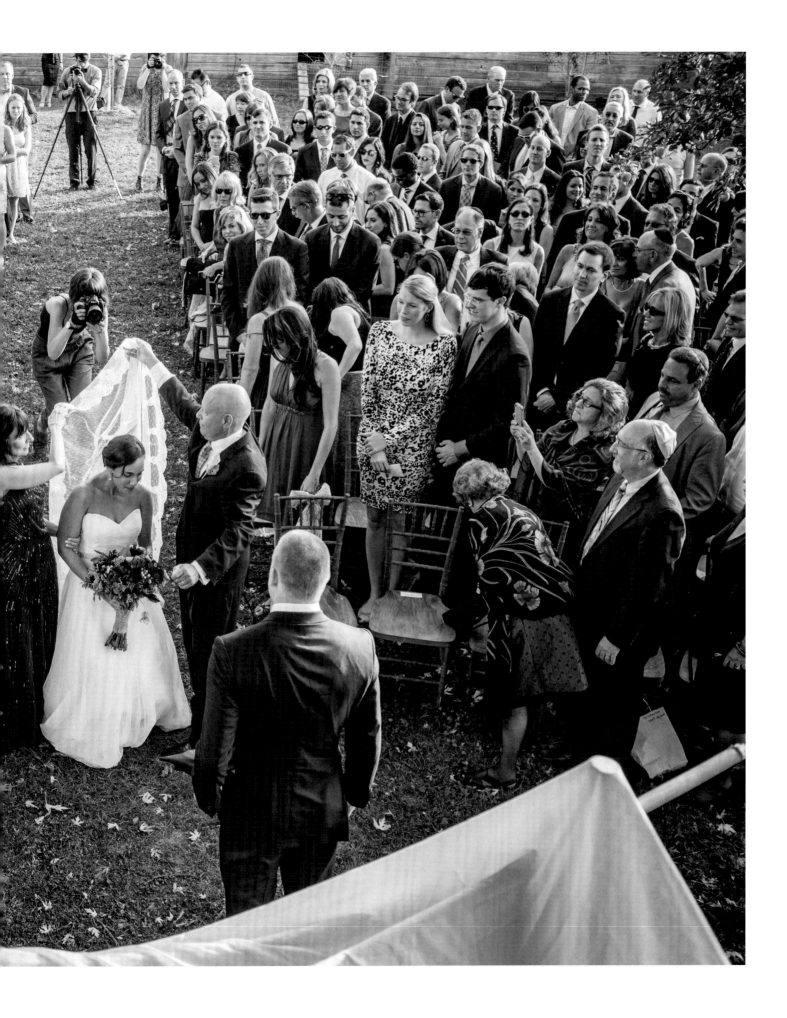

There's nothing like having a partner in life to share the good times and the bad times.
There's nothing like having a partner in life to create a direction and a
destination, to try and work toward it and be totally committed to each other.
If it works or if it doesn't work, that's okay, because we trust each other,
and we love each other, and we mold each other. — Dad

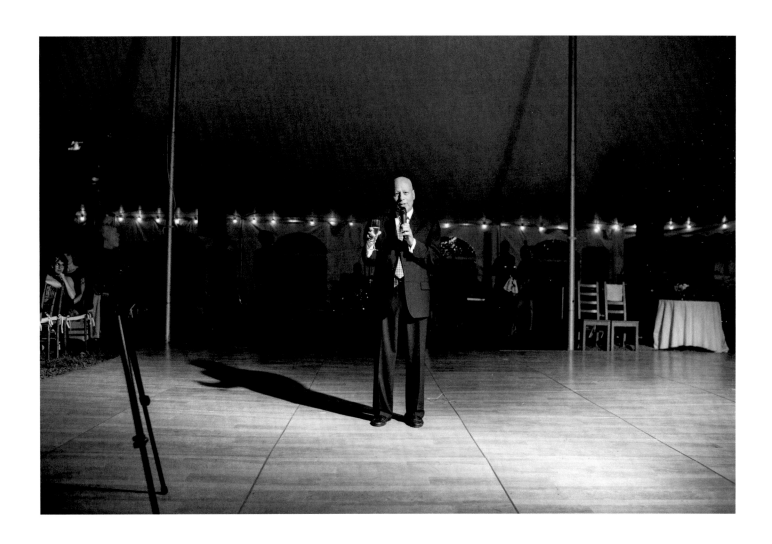

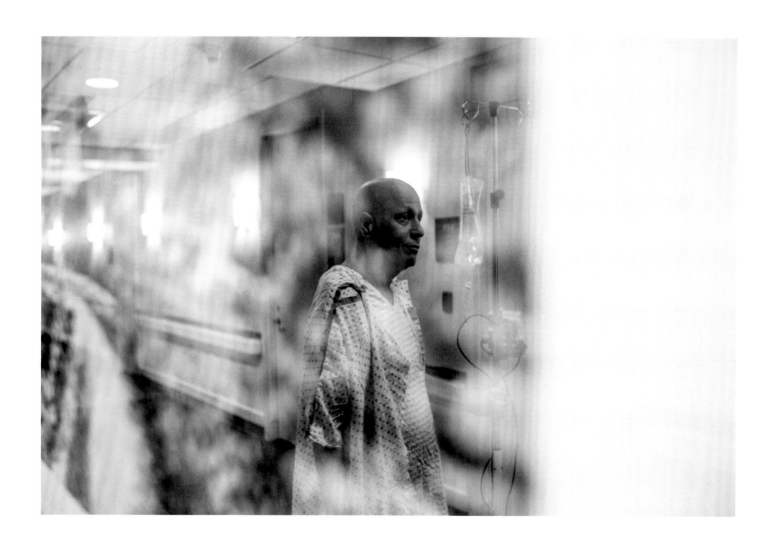

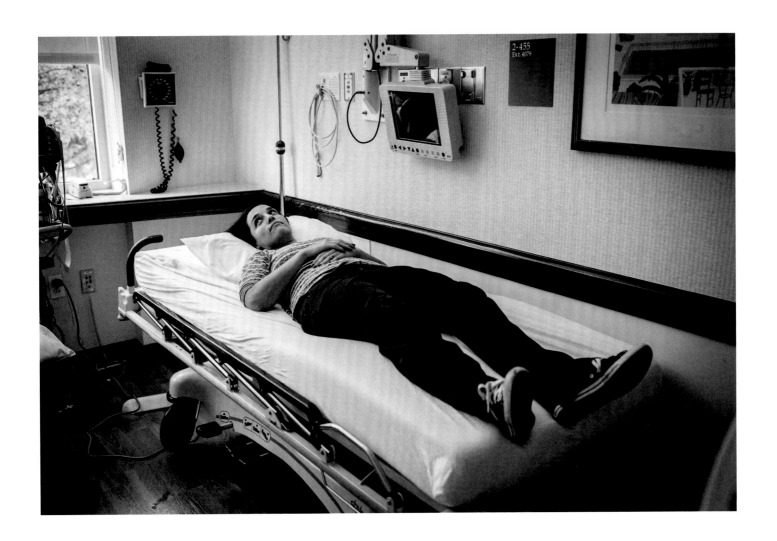

I was at the hospital with Dad because he needed yet another procedure. Camera on the windowsill,
I watched as the nurse struggled to find a strong enough vein in Dad's arm for an IV.
My mind went blank and the next thing I knew I was being escorted into a nearby room and laid
onto a bed. Did I faint? This made no sense as I had spent so many weeks in the hospital
with my parents. This was the first time I wasn't photographing the reality of what was happening
in front of me. A few minutes later, I heard a familiar giggle coming from down the
hallway; suddenly, Mom popped out from around the corner and snapped
this photograph while declaring: "Oh, how the tables have turned!" — Nancy

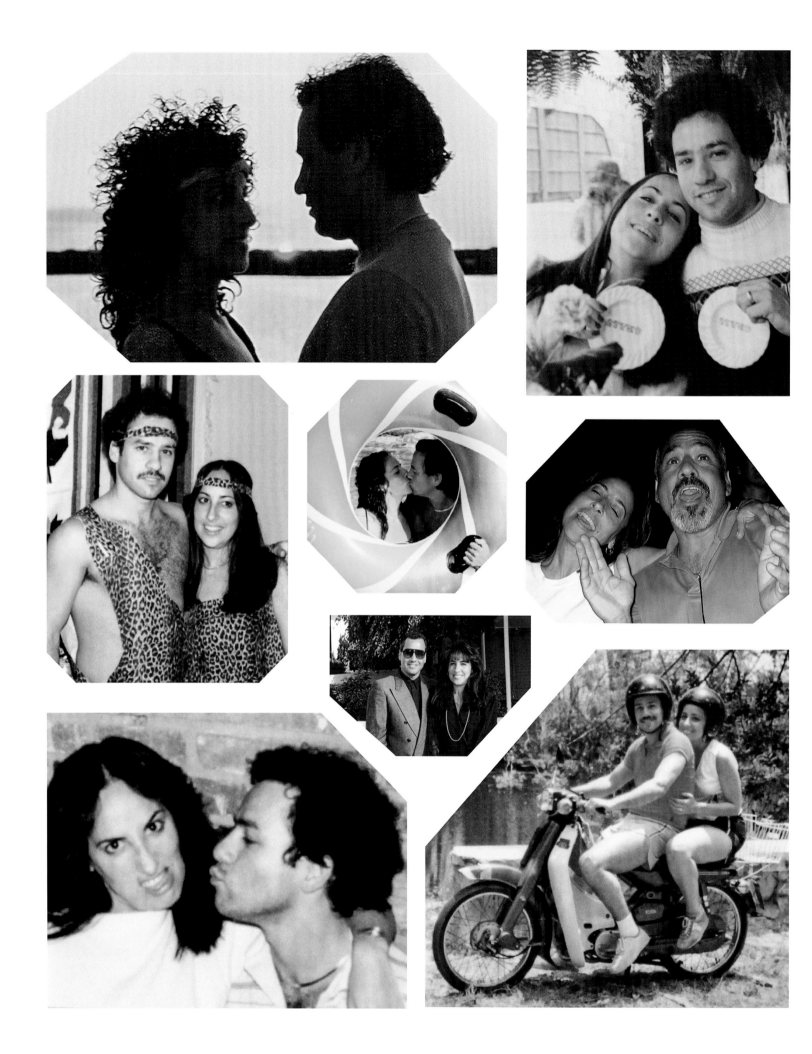

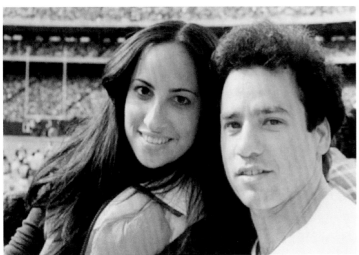

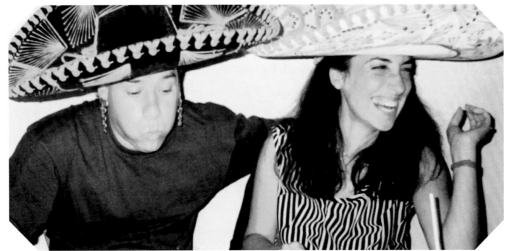

My thought is, don't waste time. You only have one life to live, don't sit on your ass
and watch TV. Go out and do things. Be with people. Make friends. Make good friends.
Have experiences. Mom would say: "If you're going to do something, make it worthwhile."
If you're going to have a house, make it a home. See five things instead of ten things
and enjoy those five things. Don't rush through your meal. Don't rush through a movie.
Don't just put in your ticket and say, I punched this clock. Those are very important lessons.
I've learned a lot of that from Mom. We've learned a lot of it together. It's one of the
best lessons, or most important lessons that I think I can convey. — Dad

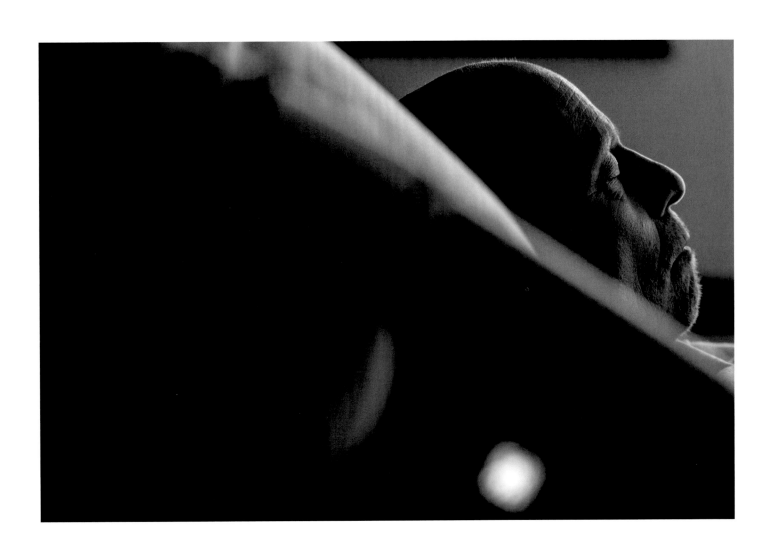

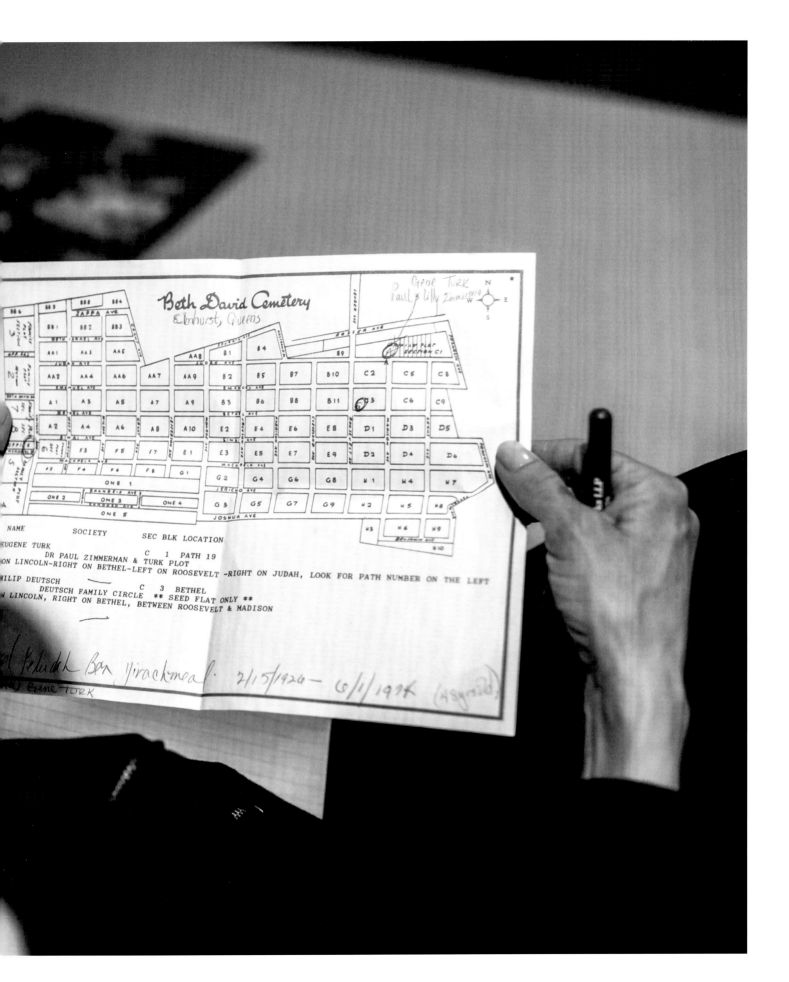

The air felt light and still that afternoon in the hospital. The nurse had just left after attaching a "Do Not Resuscitate" bracelet to Dad's left wrist. The decision had been made: if it was time for him to die, he didn't want to be kept alive with medicine and machines. In hindsight, I now see that this decision, his decision, was a gift for our family because his wishes were clear. During a time so completely out of his or our control, there was a sense of relief in knowing that he had a say in his life's end. He was no longer living a life of quality, and he had come to terms with this. — Nancy

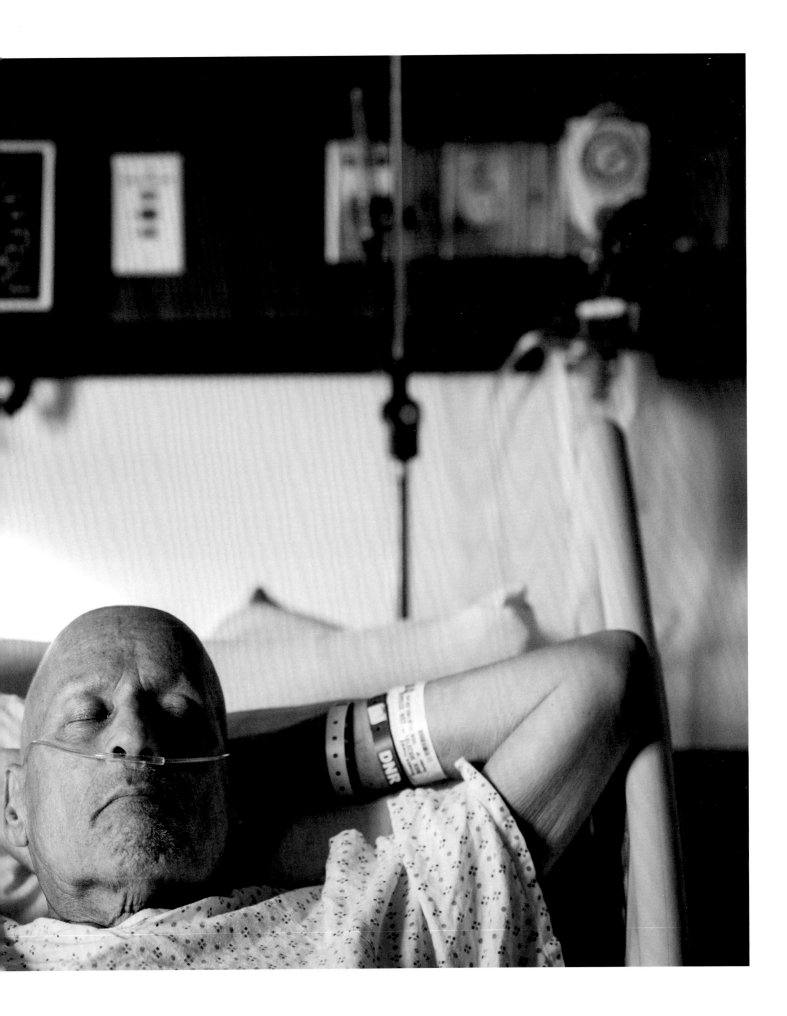

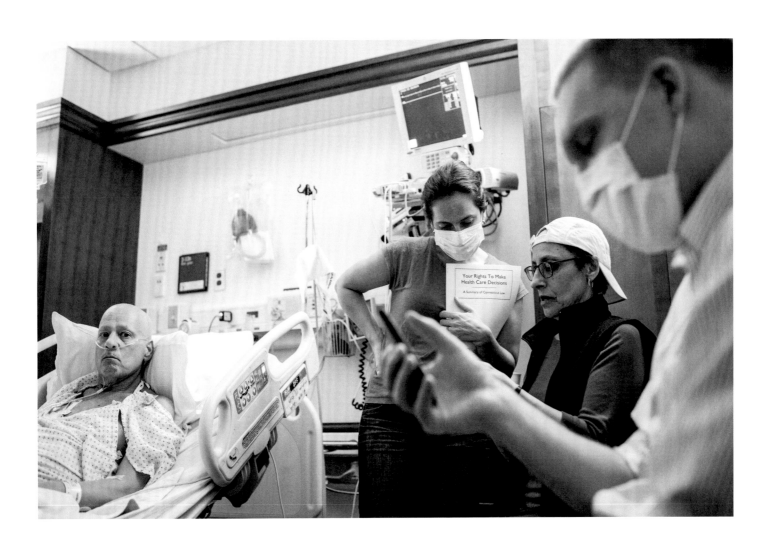

It's not the data that I want. It's the meaning behind the data. That's one
of the things, I think, that doctors are lacking. Because they do give me the data,
and they show me images on the screen, and maybe I push them to do that;
but in my heart of hearts I want the meaning behind that data. How is
that going to affect my life? What does that mean to me? That's really what a
patient, or person is looking for. I don't care whether you're a woman trying
to get pregnant, or a person who's ill, or a kid who broke their arm. I want to know:
What does it mean? How is it going to affect my life? If I were to talk to a med-
school class, that's what I would want to talk about. That's what patients need. That's
what they want to hear and I don't know how that can be taught. — Mom

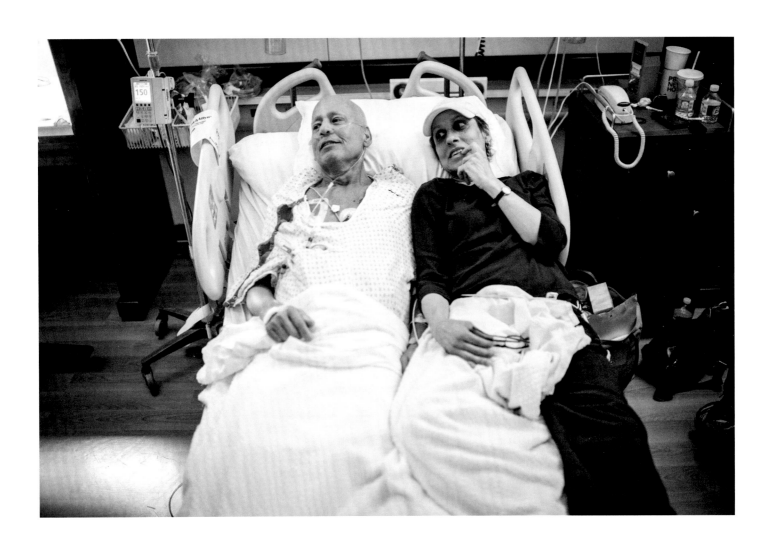

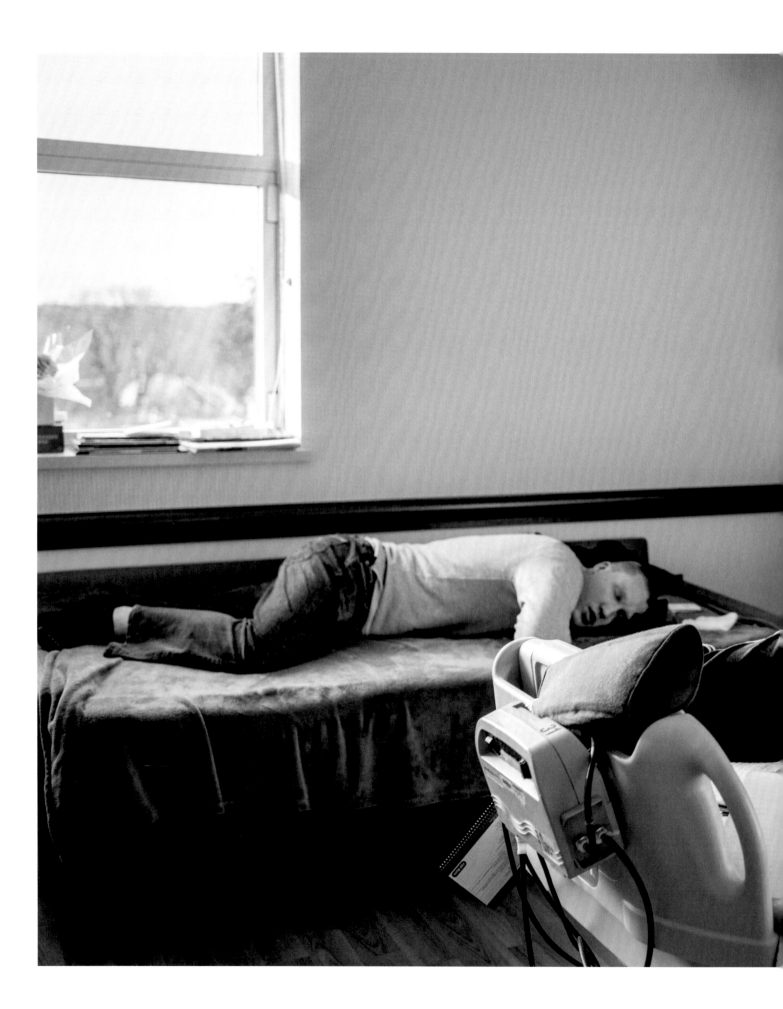

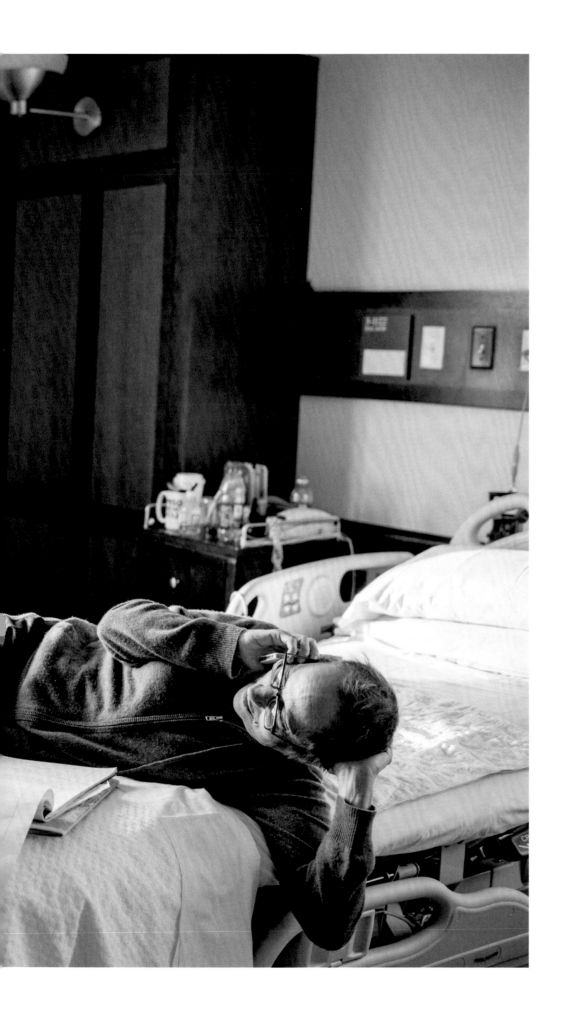

Dad never expected to live as long as he did. Both of his parents died of cancer before he reached fifteen and he figured he would follow suit. So when each big birthday of twenty, thirty, forty and fifty came around, he celebrated like there might not be another one. Because of this, he prepared for his funeral, writing his eulogy to be read during his service. He was always the center of attention. He always had the last word. He was a lawyer by trade and being a passionate and vocal advocate was a large part of his identity. This eulogy would be his final closing statement. — Nancy

I ove but before my FUNGRAZ

When Howie was diagnosed, almost from the first day he sort of gave up and said:
"I'm ready," and I knew that this was going to happen, having lost his parents.
He spent all of our married years telling me how ready he was to die. Death came up a lot.
For me, having been ill for a long time, I've always lived on a lot of hope, fighting,
not giving up, and wanting to live! It frustrated me a lot, when Howie was diagnosed
because he was throwing up his hands and saying, "Okay, well, I'm ready."
Initially, it was a combination of frustration and anger that he wasn't really fighting.
I mean, he did go to chemotherapy, but his attitude was that way. I wanted him to
participate in getting better. Whether that was realistic or not, I thought that it would be
therapeutic and healing for him. I didn't want him to get sick. I didn't want
him to die! But that's what *I* wanted. So I guess, the transformation for me was
beginning to understand and honor that it's his life, but it's also his death! He gets to decide
that—as much as a person can decide. It's not my decision, it's not the kids',
and it's not anyone else's. He has to decide if he wants to be here or not. It took me a
long time to accept that he was done being here. So when I talked about this transformative
place that I eventually came to, it was just being able to begin accepting and not be
angry, not be frustrated, and not be hurt because I had to honor that this is Howie's wish.
This is who he is, and I love who he is, so I have to love this decision. You know?

There's a fight between your intellectual and your emotional states.
Uncle Richie said to me: "Let go of him. Let go."

I said: "No, of course not. I want you to try every last thing. I want you to
keep trying." That was my emotion talking, not my intellect. I always thought there
was a way for him to get past this, a way for him to live. — Mom

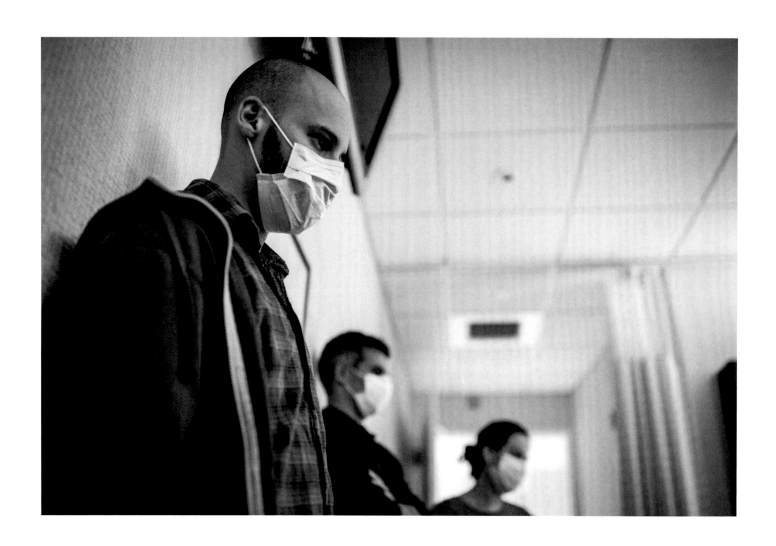

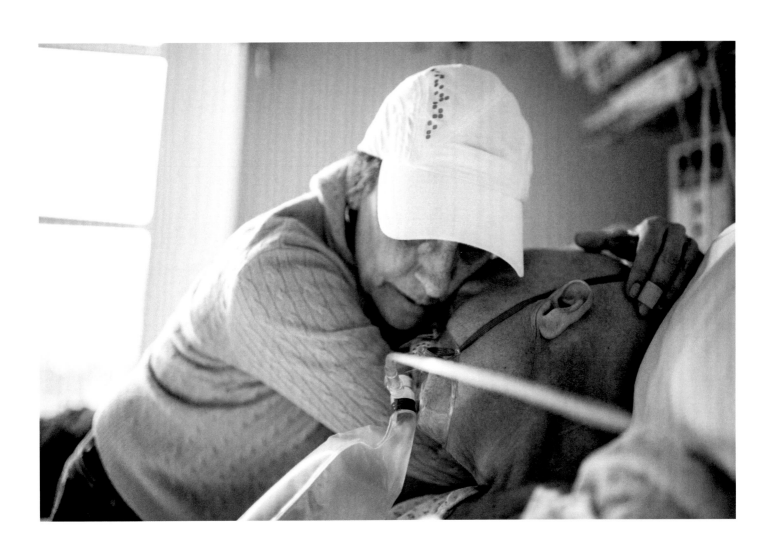

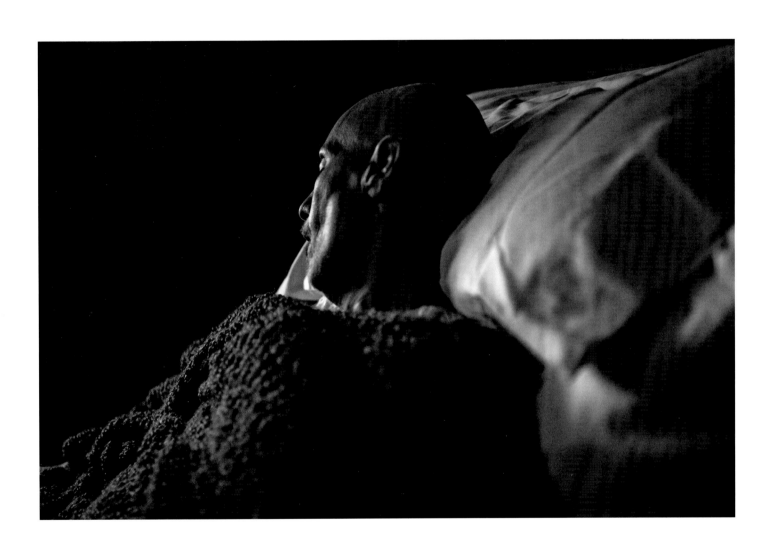

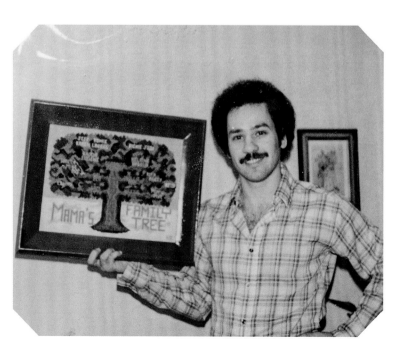

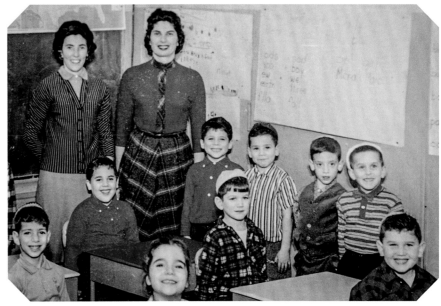

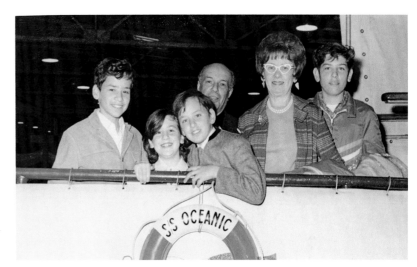

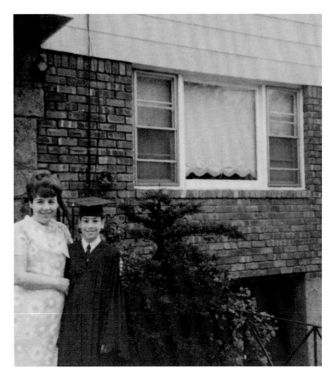

Dear Dearest,

Well, I am off. I have always been a bottom-line guy and that is the bottom line. While most won't understand, the pain was substantial and needed to end. I tried to deal with it, have tried for decades, as did my family, friends, and doctors. It is just my time to find relief, and this is my farewell. I have lived fully, loved completely, and been loved by those that mattered most and have appreciated every blessed day more or less. Sometimes reckless, other times too close to the edge, but always gratefully. Remember what we Borowicks already know: the universe never promised any of us longevity. I have outlived each of my parents by decades, and lived well beyond what I had predicted or ever bargained for ... longevity aside, you should know, if you do not know already, that I believe I have been the luckiest man to have ever lived on this planet, so I am comfortable with the time I had. My kids, Jessica, Nancy, and Matt. Wow. Three beautiful flowers in my garden. Thank you for your love and what each of you has contributed to the magic of our family. Look for me in every sunset.

Laurel, my raison d'être. My Valentine for a third of a century. I've been the luckiest in love, to fall in love and share a love with you, truly beautiful, funny, elegant, and graceful. A genuine and sweet person as you all know, I was never even nearly worthy—who would be? Heroic in your battle with your cancer and my mishegoss ... patient, indulgent, loyal and with an intuition, intelligence, and a depth of soul few can fathom. Bumps in the road, sure, but willing to work hard to get back on track, you bet. That's my girl ... generous, selfless, and devoted to family ... considerate of everyone, as low maintenance as a person could be, my best friend in this and any other world. Forever I will be grateful for the gift of you and your love. You are tough, but not *that* tough. Laurel, I will wait for you as long as it takes ... but by the way, for once, please don't rush. Take your time. Thank you for our wonderful home, family, and life. I love you. Everyone hug someone ... it's all good. PEACE!!! — Dad

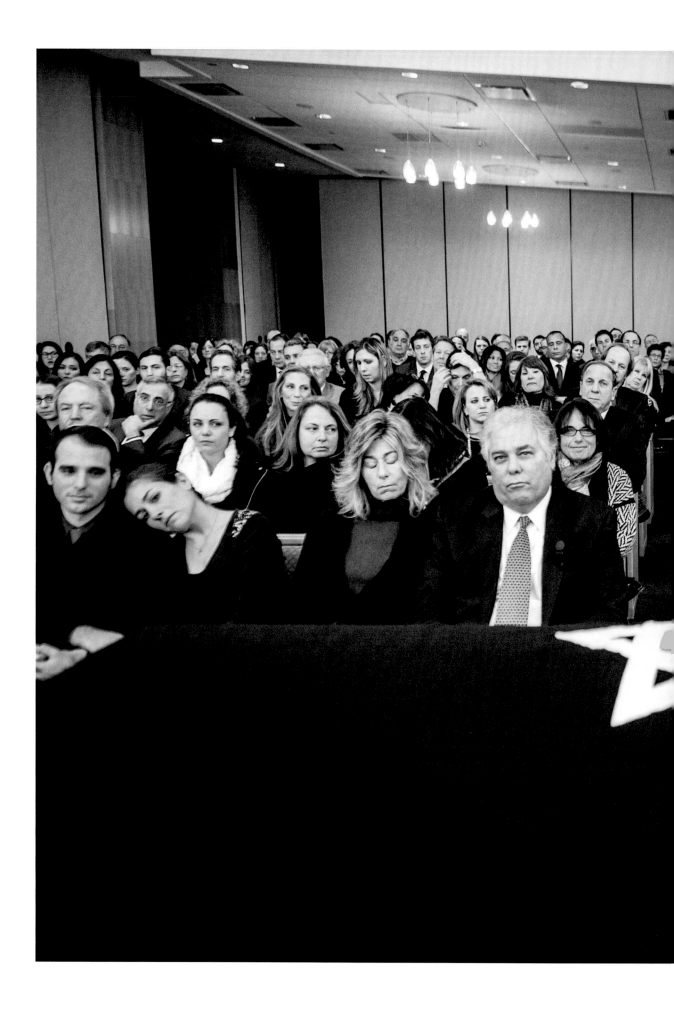

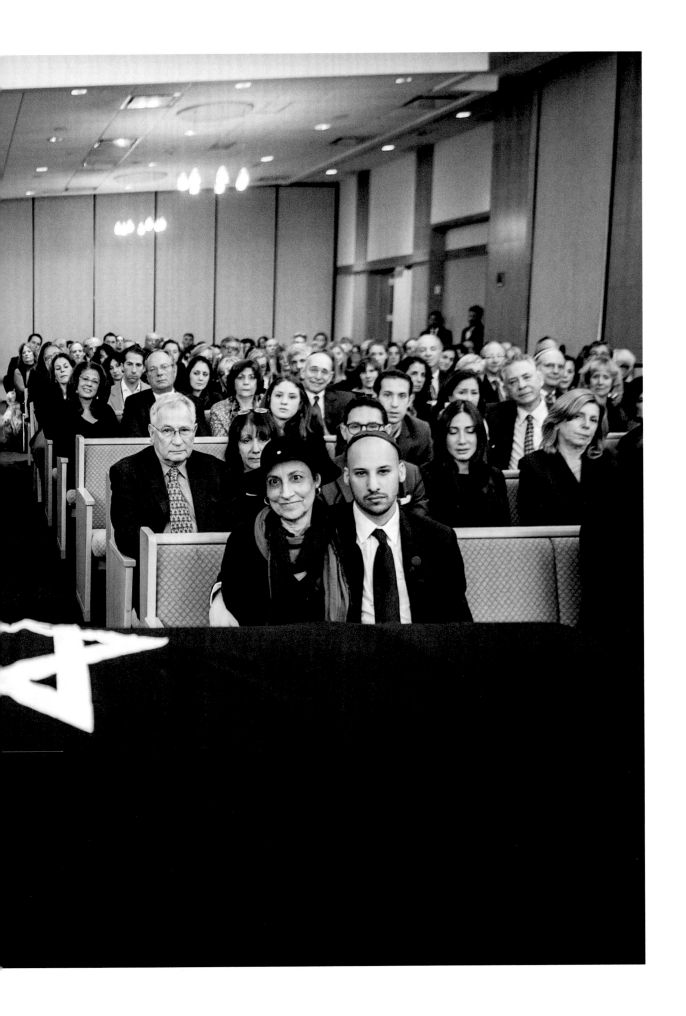

Dad left instructions for his funeral.
He requested to be buried in his favorite Giants football jersey (Lawrence Taylor, #56),
his most-loved pair of jeans, and his baseball cap with his HB initials.
Even in death he was alive, in a sense, and brought a smile to Mom's face. Dad was
always the center of attention, and here he was, front and center, surrounded by
everyone he loved and who had loved him back. If he could, he would
have attended his own funeral. That's why I think he wrote his own eulogy,
which was fourteen pages long. — Nancy

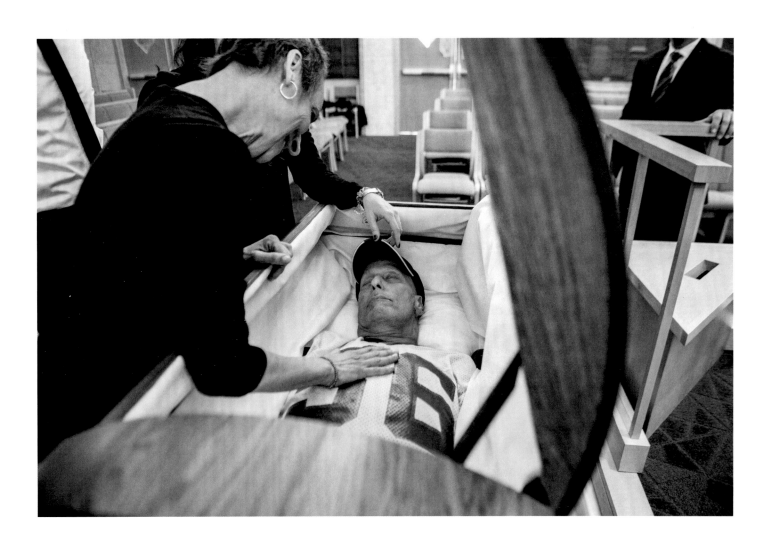

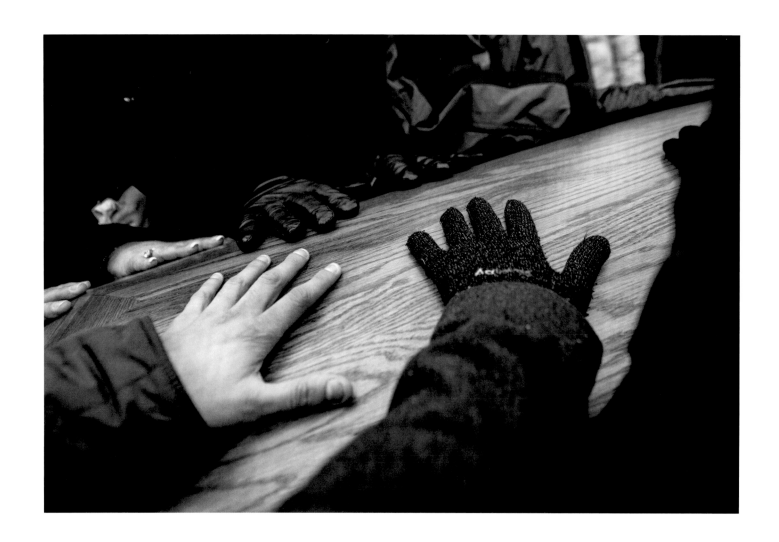

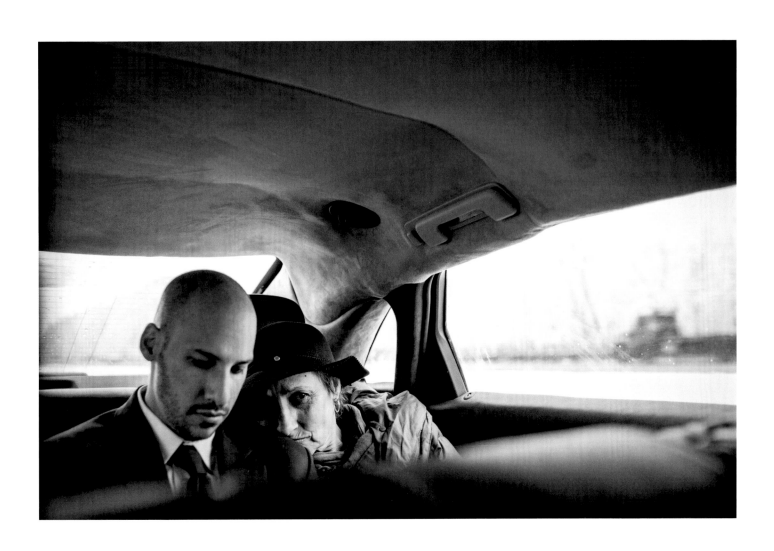

With Love,
Darling
On Your
Birthday

Describe my love?
As well
Pour out the ocean
In a shell
Or count the stars …
There are no words
To eloquently say,
You are my life--
My everything.

M. DAWSON HUGHES

Pour ton
anniversaire

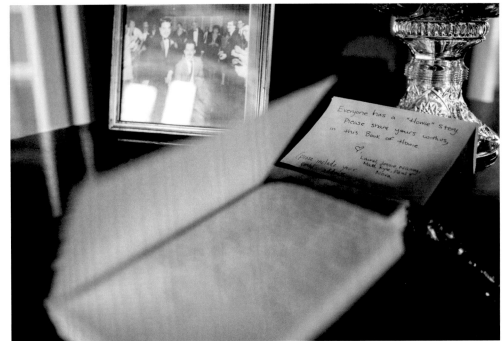

Everyone has a "Howie" Story.
Please share yours with us,
in this Book of Howie.

Laurel, Jessie, Naomi
Matt, Kyle, Nova +
Nova

Please include your
home address

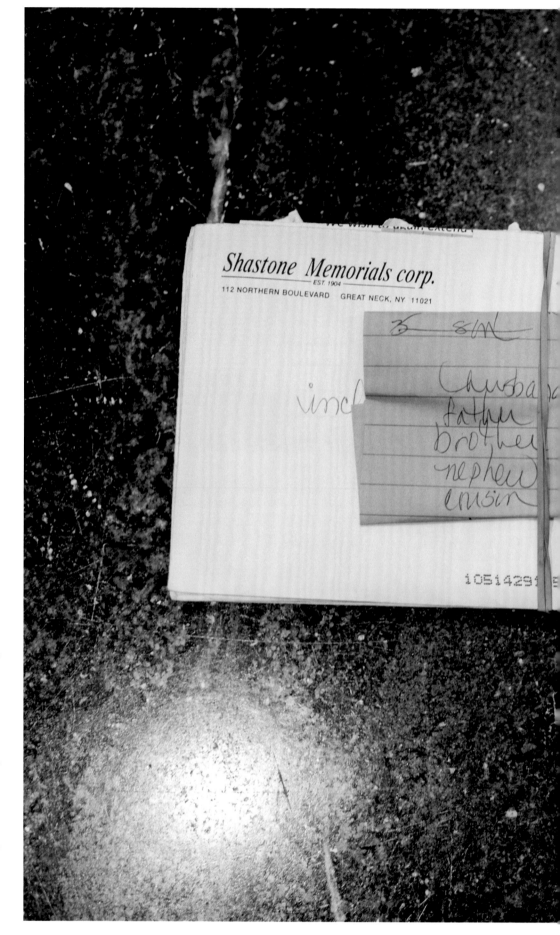

Mom's to-do lists represented the simultaneity of life: Order Howie's headstone, decide whether or not to begin radiation, join the gym and actually start going, and, most importantly, what happened to our Girl Scout Cookies?! She tried to maintain a normal life in the best way she could. One task that dragged on for weeks was deciding what would go on Dad's headstone. I think this was partly because in addition to grieving the loss of Dad she was also, in a sense, mourning her own death, which was becoming more and more real. — Nancy

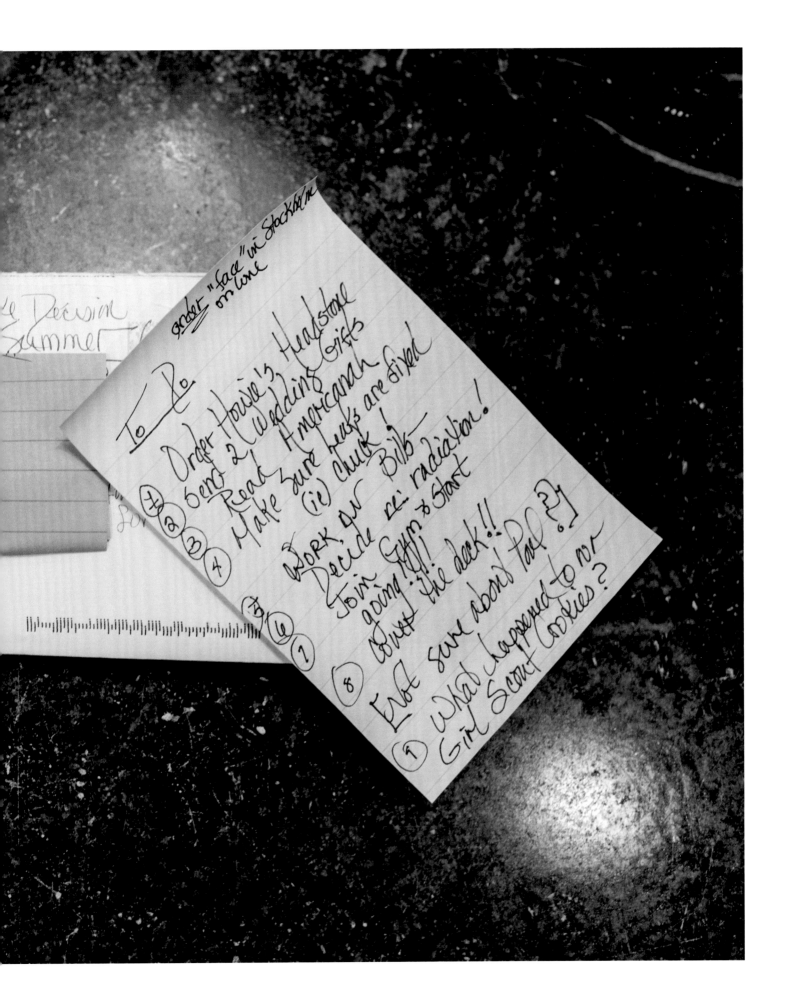

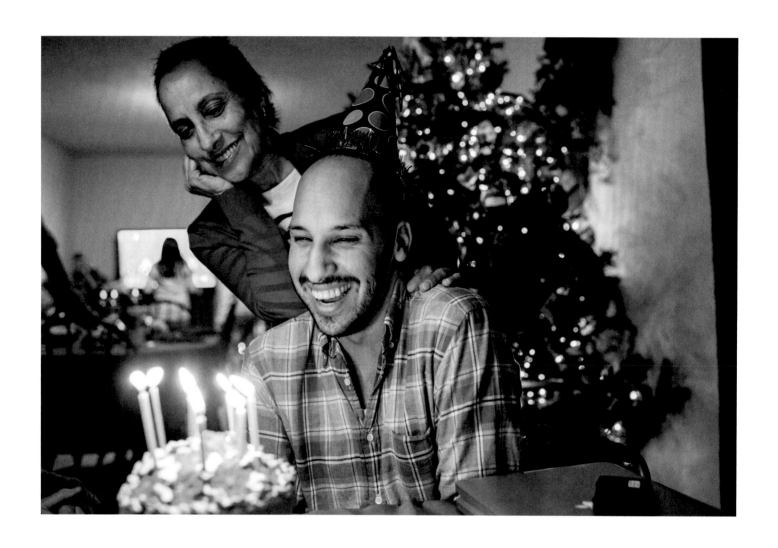

People you love live on inside of you; in your memories, in your soul, the little things you do,
the little things you think, and the way you think. Then I think you add to them
and it grows from there. You have your own experiences. To take that sort of compassion and
sincerity and move forward with it is extraordinary. — Mom

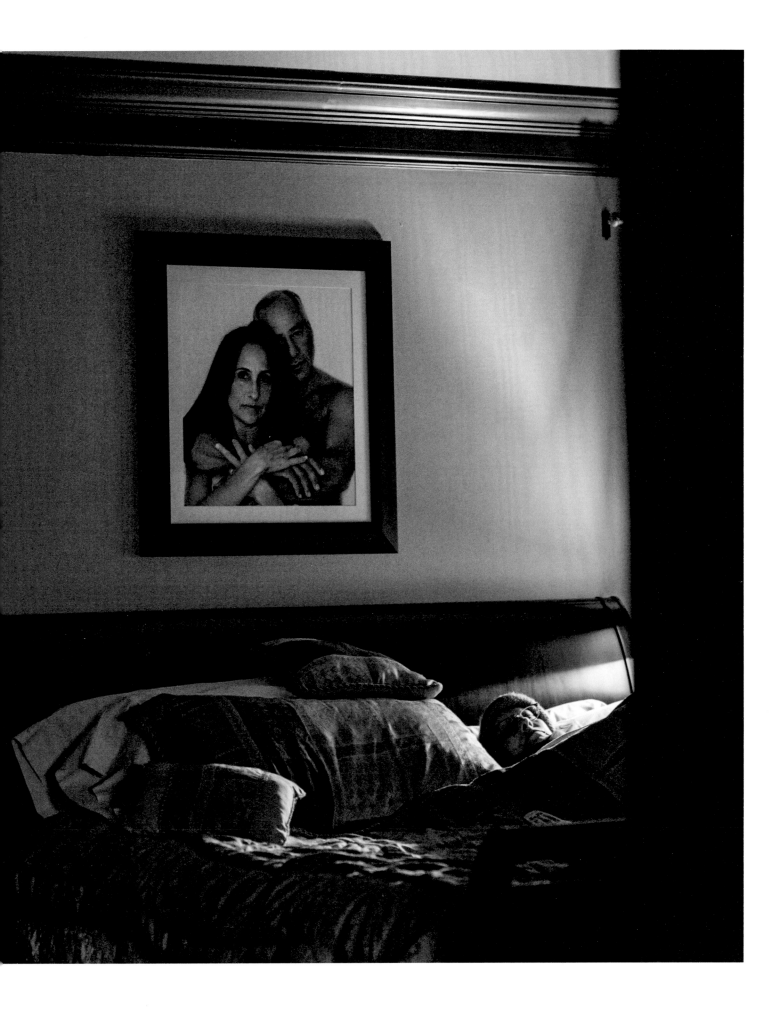

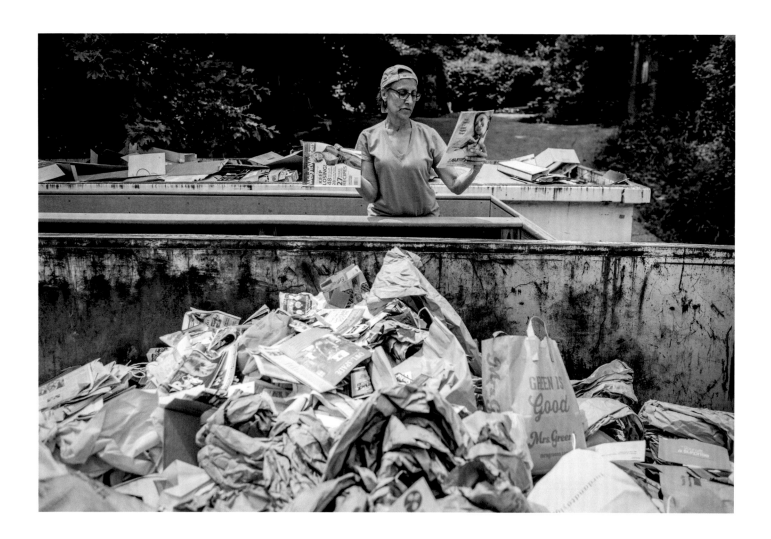

It truly wasn't until these last couple of months that I felt that adapting had become very difficult. It was harder to live with it. But I never felt like I was dying from cancer. I always felt like I was living my life, and living our lives. It just got to a point where the spread of the tumor got too strong for my body's ability to manage it anymore. Having chemo was always having hope. So I am sort of passing through the hope phase, into the reality phase, and that's a big transition. Isn't there one more chemo? Isn't there one more therapy? But there's also life going on here. I am having marshmallows, you know? So, don't lose perspective on that. Each day is one of your days. Whether it's going to work, handling a case, or wanting to kill your husband for something, that's one of your days too. It's living! I've always said to you guys that my pet peeve is when somebody dies of cancer, they say: "They finally lost their battle to cancer." It never felt like it was a battle. I always felt like I was living, and then just trying to manage the cancer. — Mom

I know I love you because now
it doesn't really matter to
me where we are or what we
are doing — as long as
we're together...
...because every time we meet
it is like a celebration and all
the things we do are love
I know I love you because I don't
feel the need to prove anything
anymore...
...because I never want to
change you. I only want you
to be the real you, me to be the
real me, so we can be the
real us.

The place where it all happened.
Good 'Ole S.J.U.

It was in

1978 when
there were try outs
for the law Revue
"Boffo goes to
Law School"

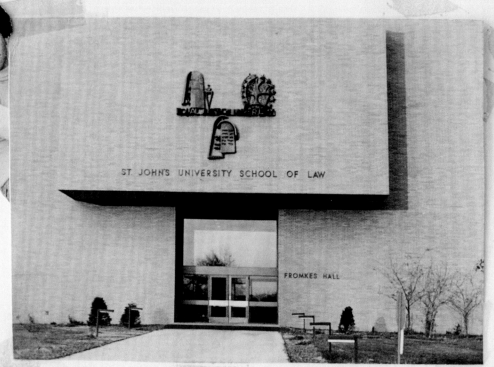

ST. JOHN'S UNIVERSITY SCHOOL OF LAW

FROMKES HALL

the B-day card that
started it!
• 3/12/78

LAW STUDENTS

Your
wedding...

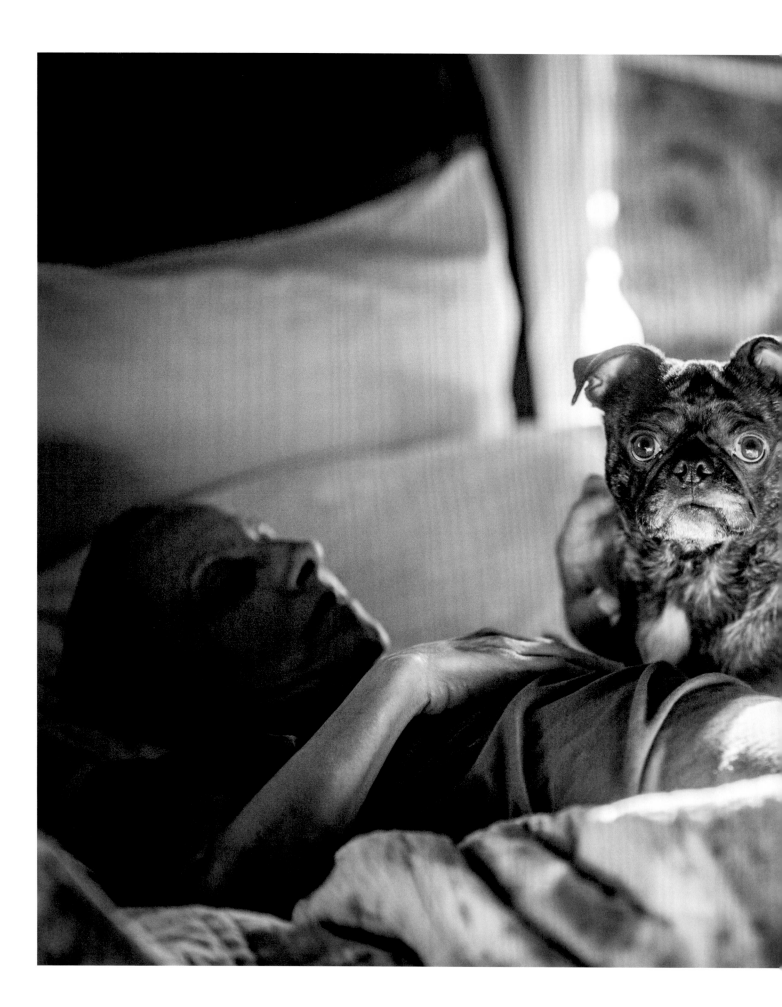

*As Mom got weaker, she did not
want to be touched. However,
she wasn't bothered by Moses,
a five-year-old Pug-Boston Terrier
mix who belongs to a close friend.
He lay by her side, and often on
top of her, bringing her comfort and
many laughs. — Nancy*

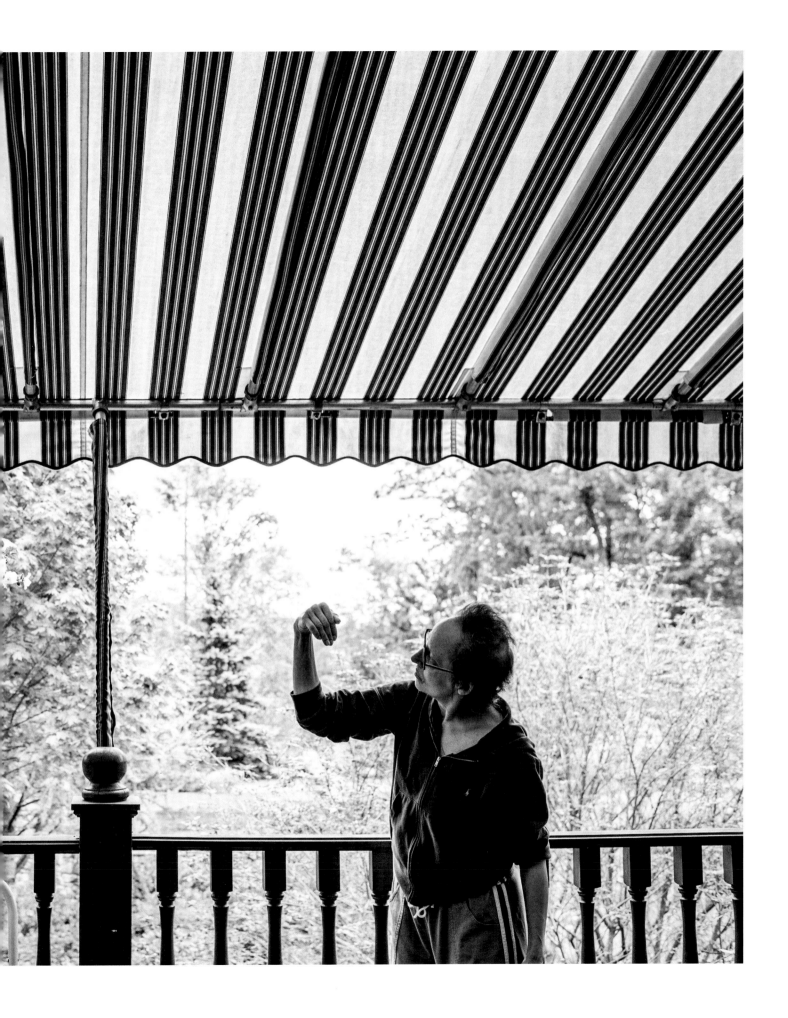

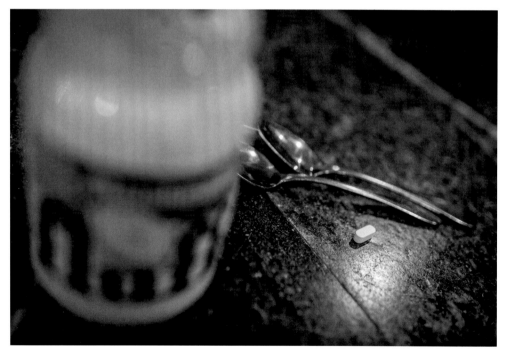

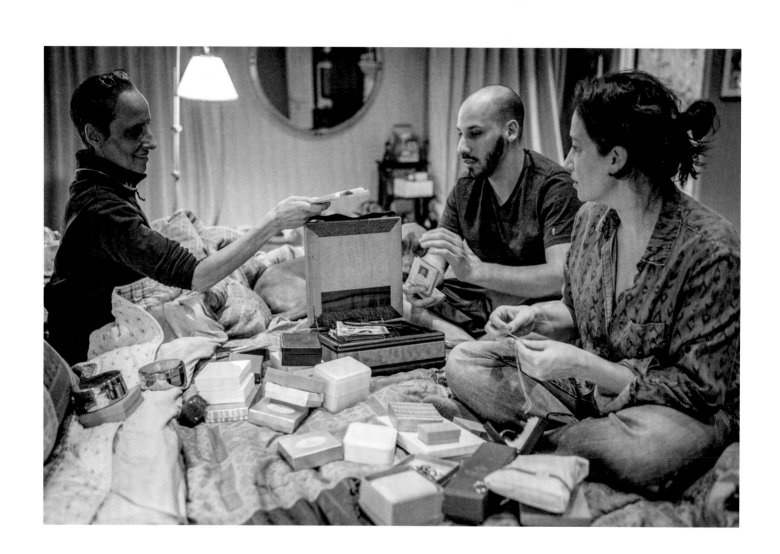

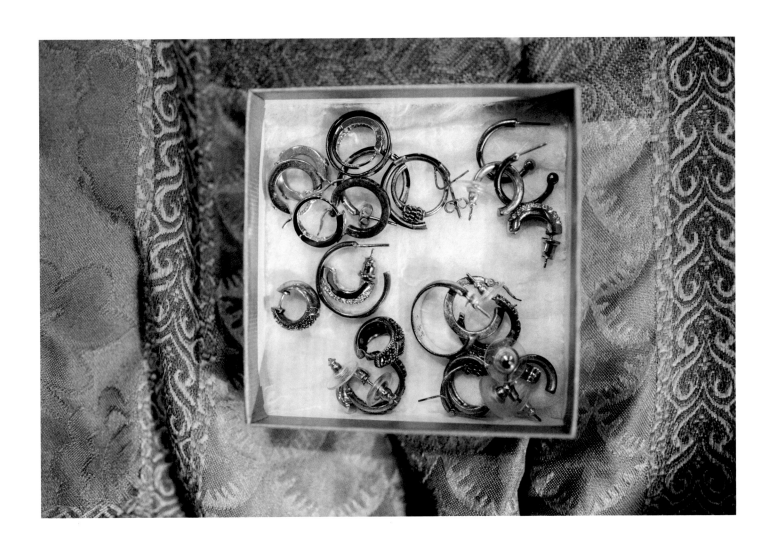

Jewelry was never all that important to Mom. We decided that we wanted to talk to her about some of her pieces
though, because we wanted to know if any of these had an unknown story, history, or association.
She was excited to go down memory lane with us, showing earrings from our great grandmother, and trying
on old costume jewelry from her high-school days. We knew that once she was gone,
the stories would go with her, and we wanted to hold on to whatever we could. — Nancy

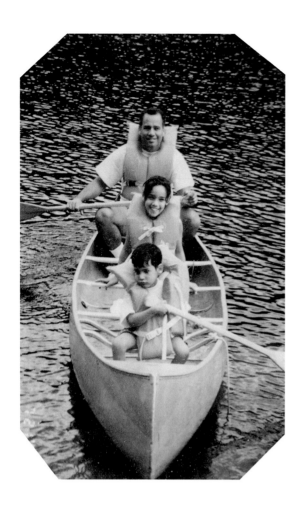
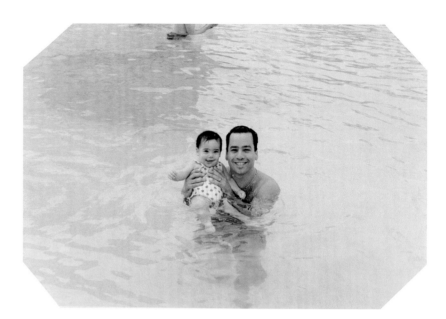
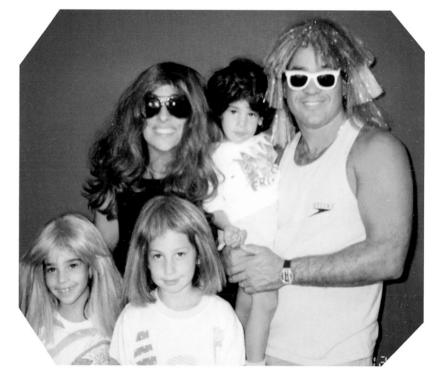
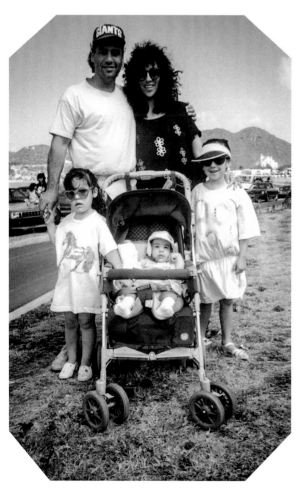
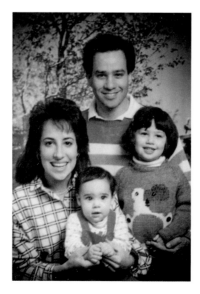
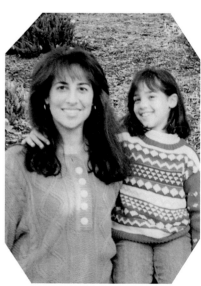

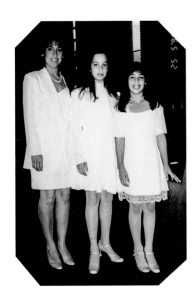
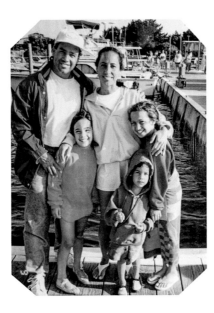
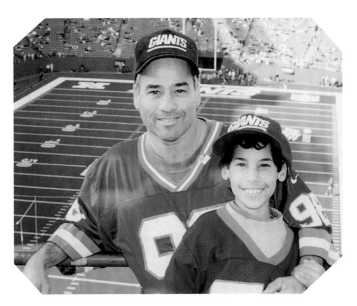
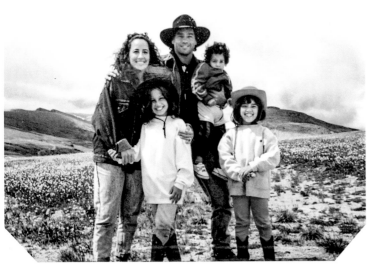
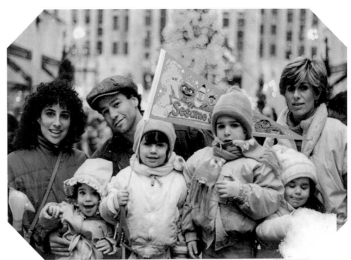
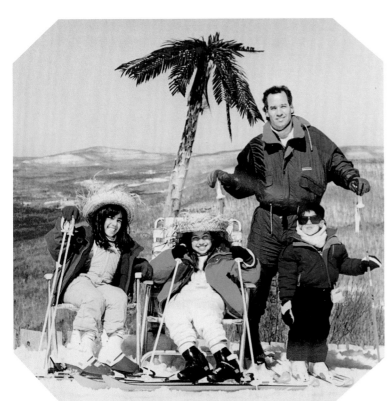
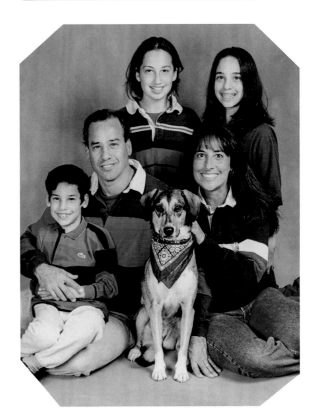

I love being with the kids (& Nora)
so much -
I can fight the pain etc, if I get
to see them & feel them close by.
I'm so lucky!

So, maybe I could / share with
the 'kids' & some friendsCookie -
This will be hard for me - I try to
appear strong, "normal", "fun"
or "at least O.K.", I don't really
want people to worry about me -
"a la Marion Turk" upbringing
maybe this is wrong (for me) this
kind of thinking may be good for
"survival", but at what cost?
There is a formality a kind of
separateness even coldness in
the small Turk family compared
to the warm overexpression
of "family" that was always
evident in Mama & Helaine's
house.

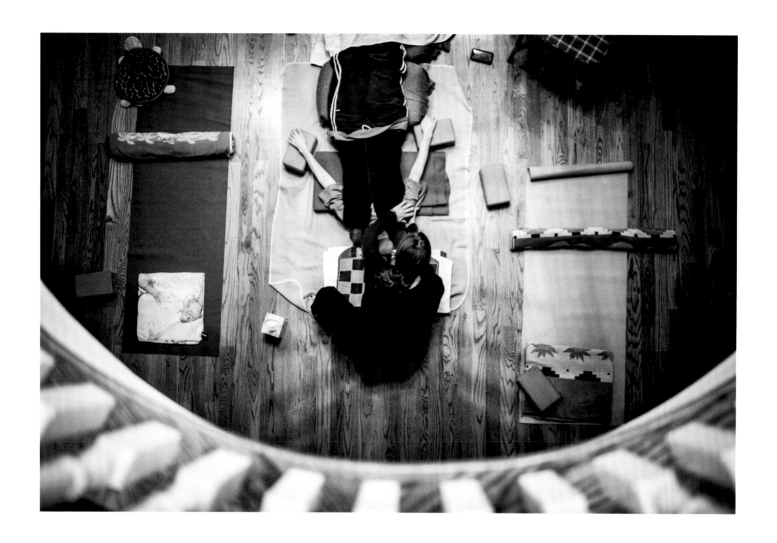

There's a sense of urgency to things. It's kind of shocking. What if I wake up tomorrow and there's one less
thing I can do? I can't get out of bed, or I wake up and start to feel the drunk and dizzy thing that
Richie talked about when you are dying. It's not that I'm nervous, it's just that I feel like I better get my ducks
in a row because this is just going a lot faster than I expected. Then there's a little piece of me that says:
"What if I hadn't gotten that PET scan? What if I hadn't seen the PET scan?" Would I have just woken up every day
thinking: "Ugh, I feel really lousy," but wouldn't have the overall thing of: "I'm dying."
Would I act differently?

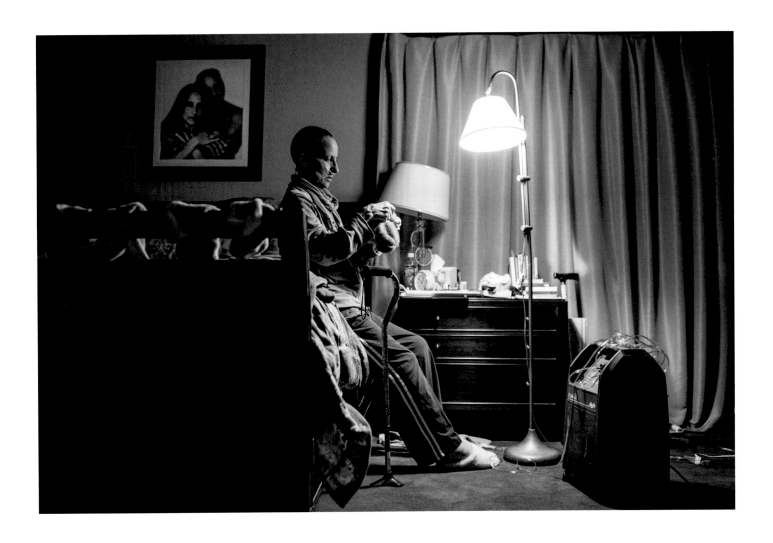

I felt a sense of relief the day Dr. Boyd came by to discuss hospice care. I had been thinking that was the direction it was going the last couple of weeks, because my stomach was hurting more than normal, and it was starting to blow up, and my feet were hurting. Everything just seemed to be intensifying. I would look at my bloods and they were getting worse and worse. It was like something I knew on a deeper level, so there's sort of this anticipation of it. Somehow putting a label on it just made it something that was not controllable, but also, somehow not as scary. I feel like you can't even begin to start lifting that heaviness until it's done. There's a conclusion, so you can move on with the next part of your life. It's something that was inevitable. It's the circle of life. So, it's my time to move over and make room. — Mom

Pill Journal

PAIN JOURNAL*

Issues Hope No Hope
 Control No Control
 Fear More Fear
 Unknown Known
 Future No Future

I don't know how to do this anymore.

Another brain scan
Another biopsy

Is there a point?

Kind of dread going to my Boyd
appt next Week — I'm afraid
I'm just going to cry thru it —
Better take someone with me!

Does everyone, except me, think (disability, decline, death) is so near?

Am I the only one who still has hope for some of life ahead?

Even Dr. Whitney, Bennett & Boyd are pushing the pain - pill - mngmt - - Is it inevitable that soon I will be in great pain that I should start on pain pills (narcotics) now.

Maybe, this is some sort of <u>denial</u> on my part, but in my <u>head</u>, heart & soul I don't feel like I'm dying then again I don't really know what that is' supposed to feel like!

My bones (hip etc) are stiff in the morning - but as the day goes on, I am more limber.

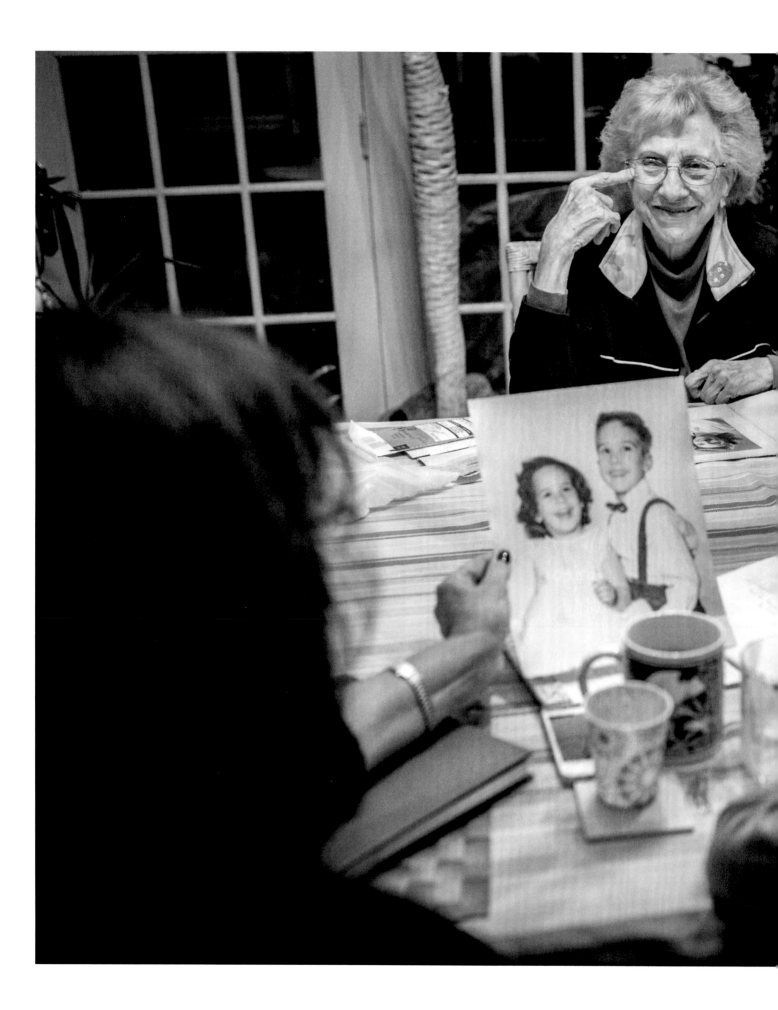

Small Bucket List

Mani-Pedi
Thank-you to everyone for
Kidnesses - soups - invites
Call Rabbi & other Rabbi / gifts beauty praying
Talk to Grandma

Total talk to: Deb R.
& Jamie & Paul

1. Talk To Kids –
 (Pre-Funeral)

① Funeral at Bet - Torch or Remem?
② Kid's Letters
③ Eulogy
④ How Long Eulogy / Shiva?
⑤ Jewelry in closet
⑥ $ in Bathroom
⑦ Put aside their XMAS Bonus

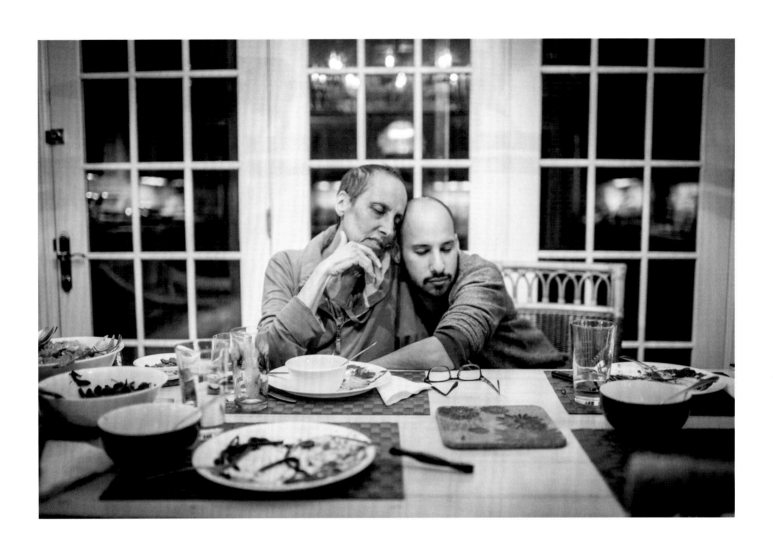

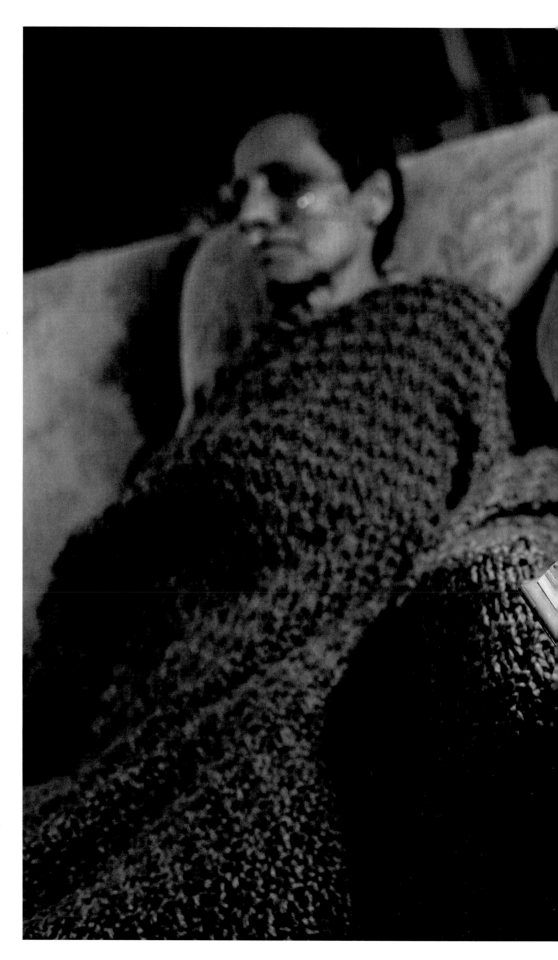

Mom rested on the couch while Grandma Marion, her mother, read to her from a book. It had been decades since Grandma truly played the role of mother to her daughter in this way. There was little she could do for her other than read and stay close. — Nancy

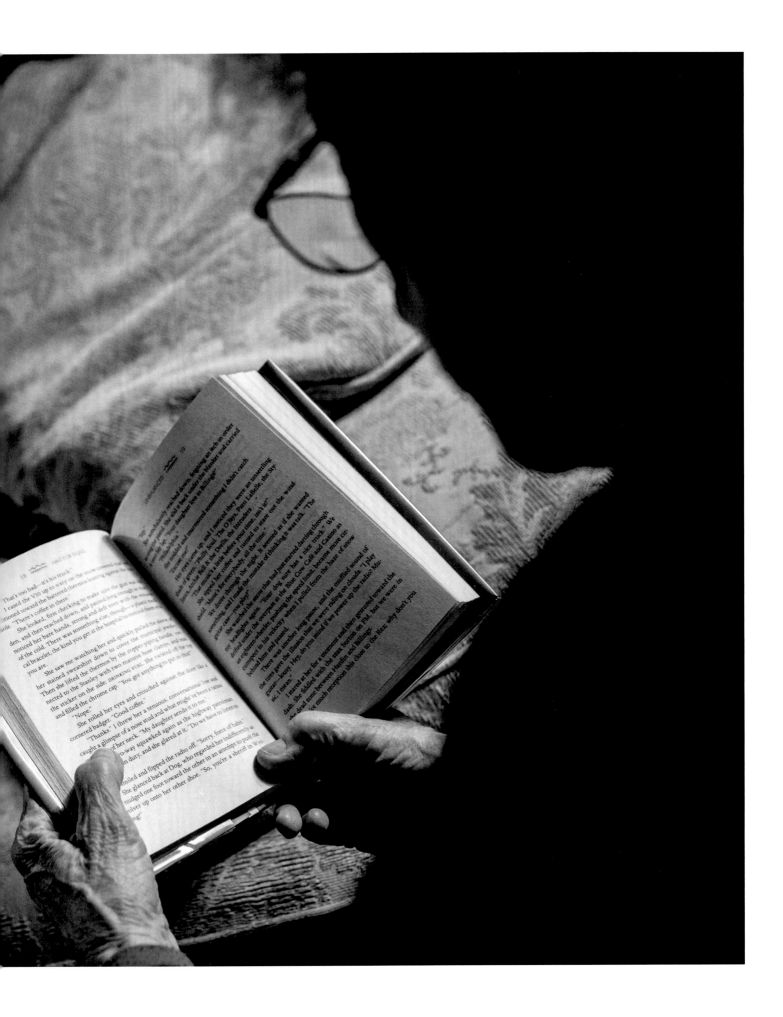

The thing I am most proud of, and one of the reasons that I think I can
close my eyes at the end and feel like my work here is done, feel like
my life had some meaning, is knowing that I helped produce three remarkable
human beings. That's a really big deal because these three
remarkable human beings are going to touch the lives of lots of other
human beings and that's what makes our world so amazing! — Mom

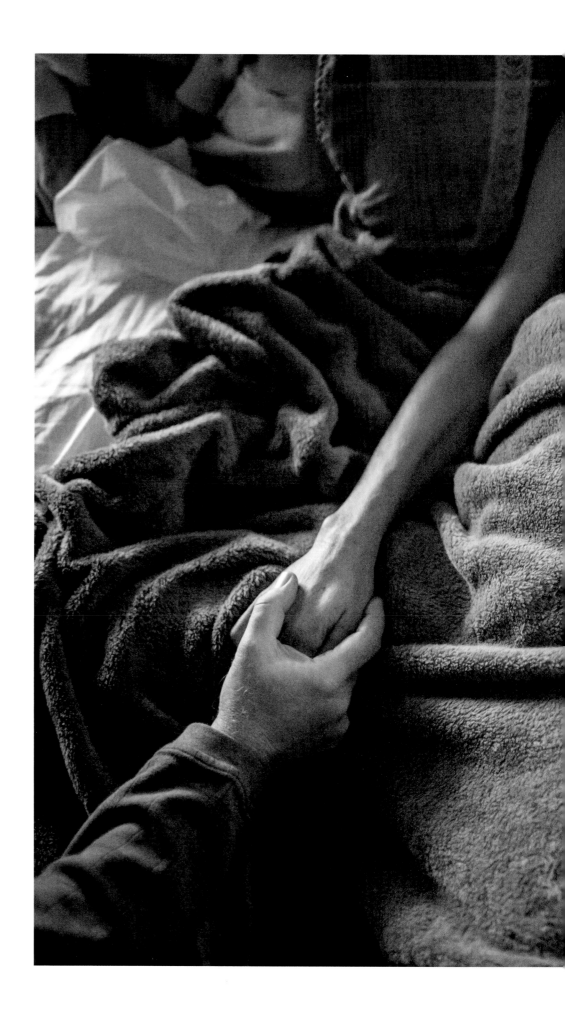

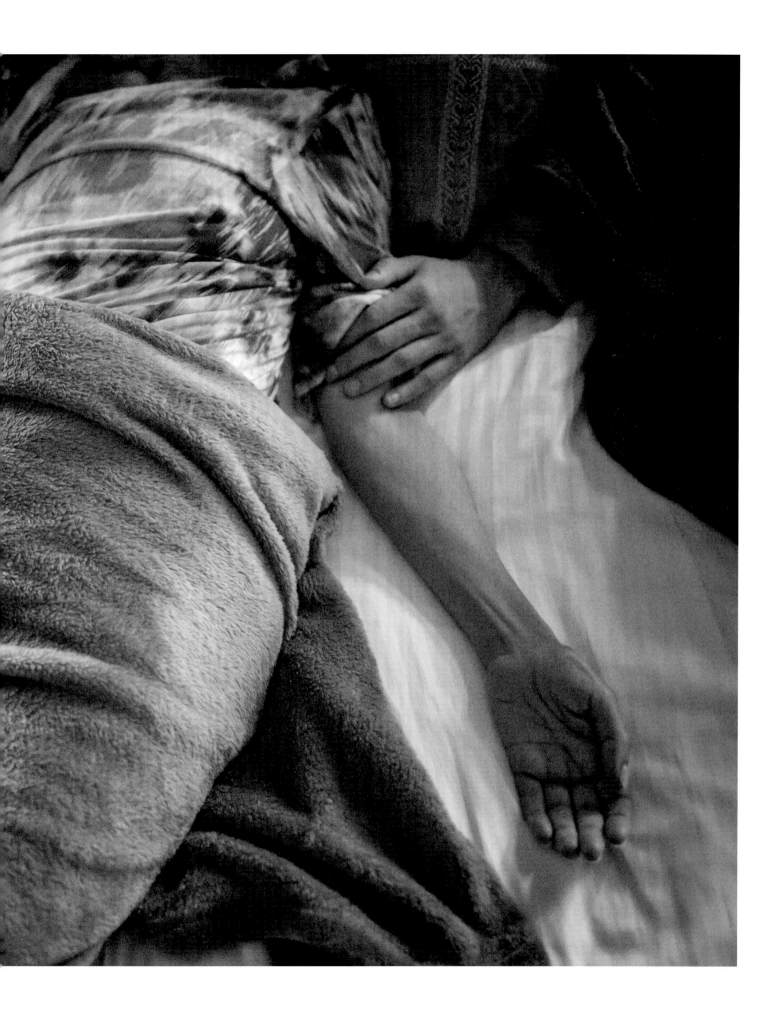

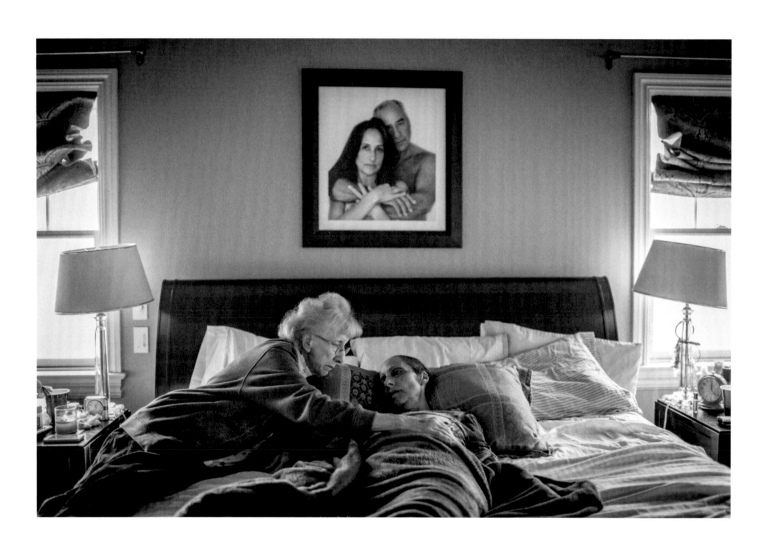

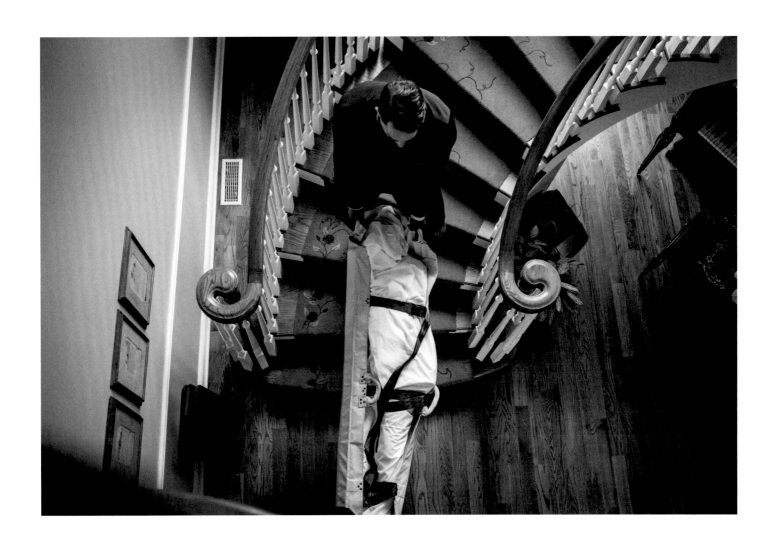

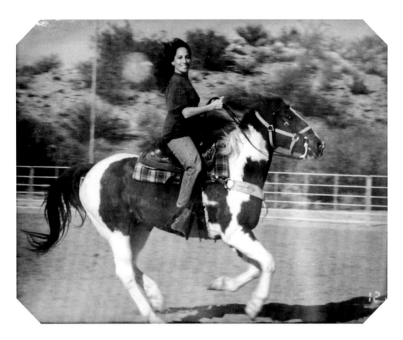
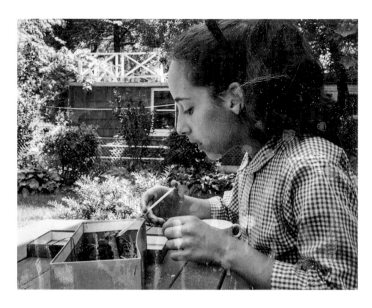

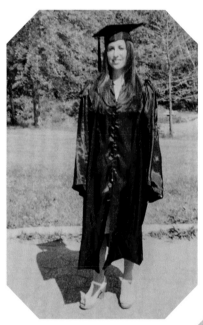
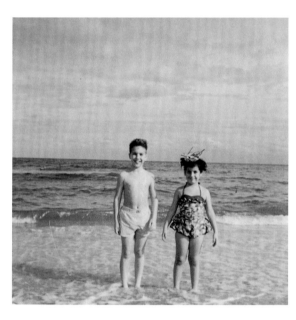
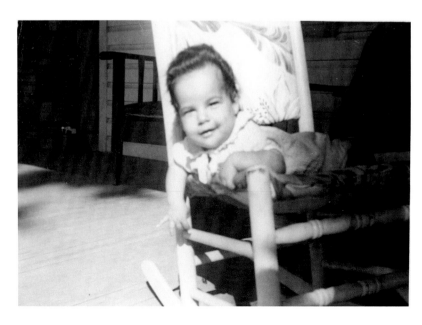
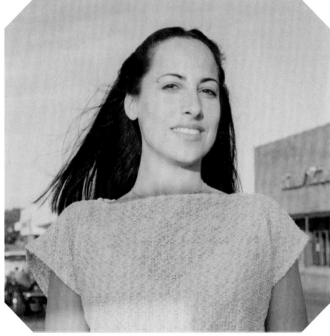

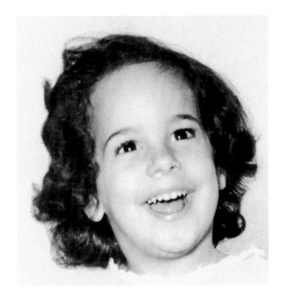
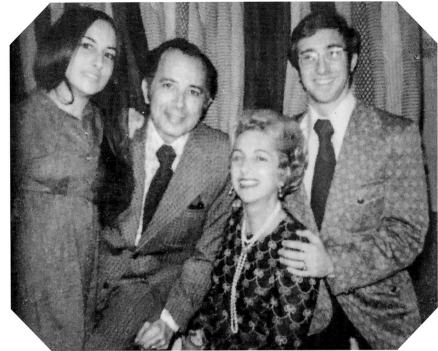

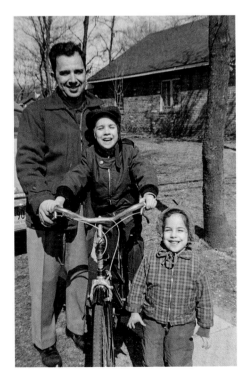
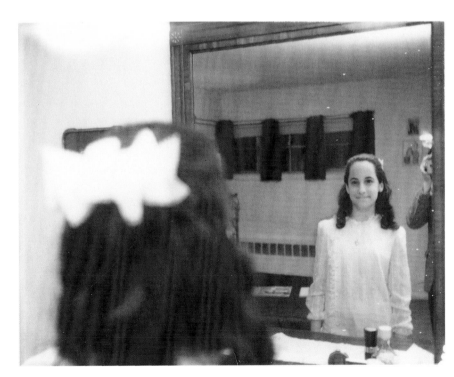

Mom died on December 6, 2014—exactly a day shy of the one-year anniversary of
Dad's death. It doesn't feel like a coincidence. It felt all too familiar being
back in the temple, seeing the faces of those who loved Mom and our family, and mourning
the death of our last parent. While it was unbelievably difficult to be there,
I looked around and realized how we were surrounded by so much love and support.
We were not alone. — Nancy

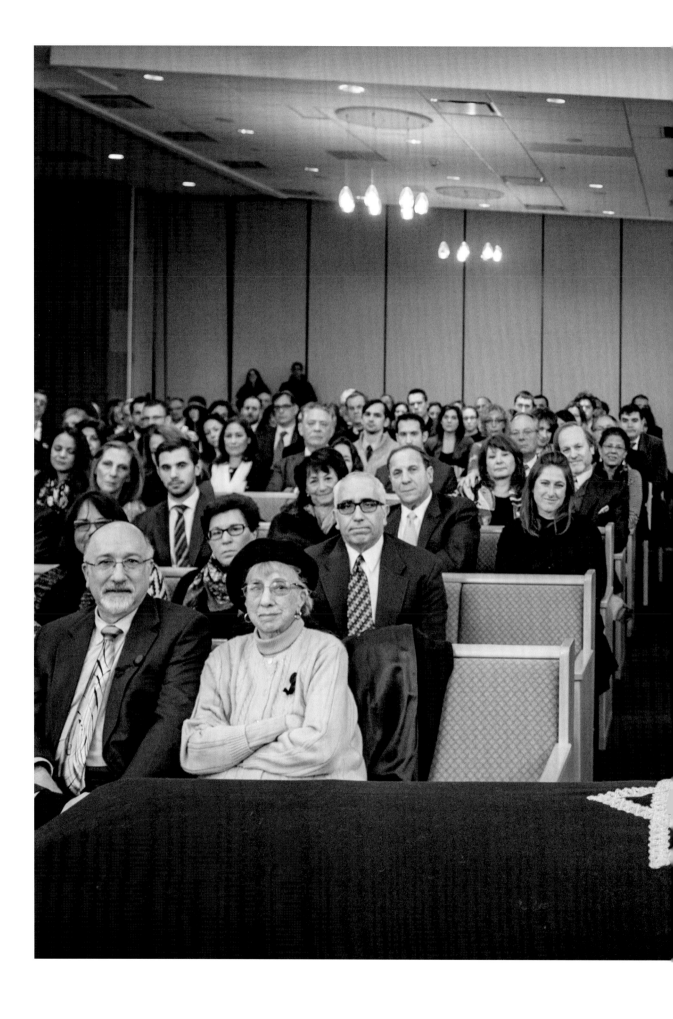

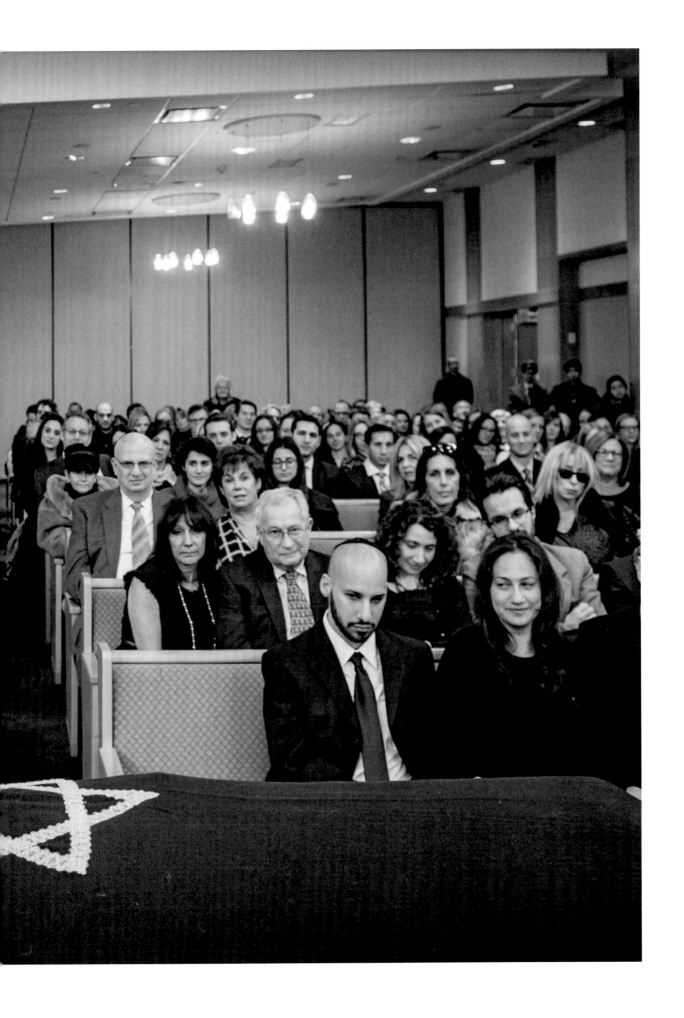

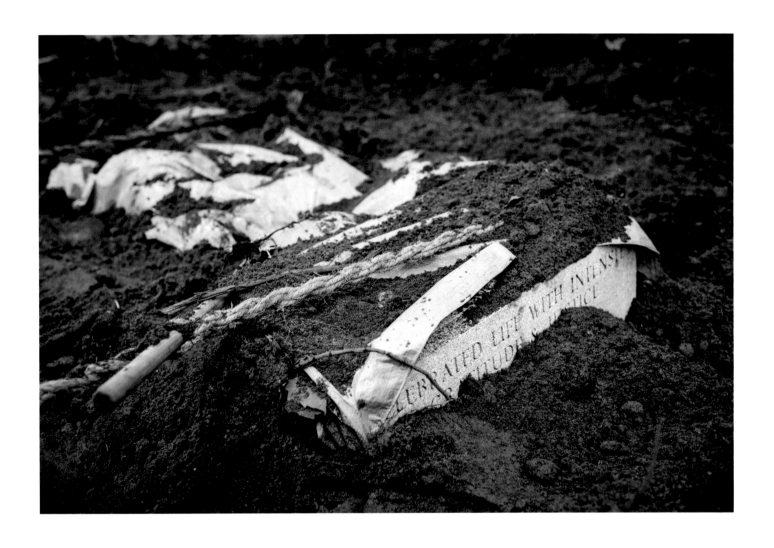

Dad's stone stood covered with cloth and dirt as we buried Mom by his side, one year later.
On their wedding day, they vowed to be together, in sickness and in health and
until death would they part. Upon death they may have parted, but I believe they are now
back together, side-by-side. — Nancy

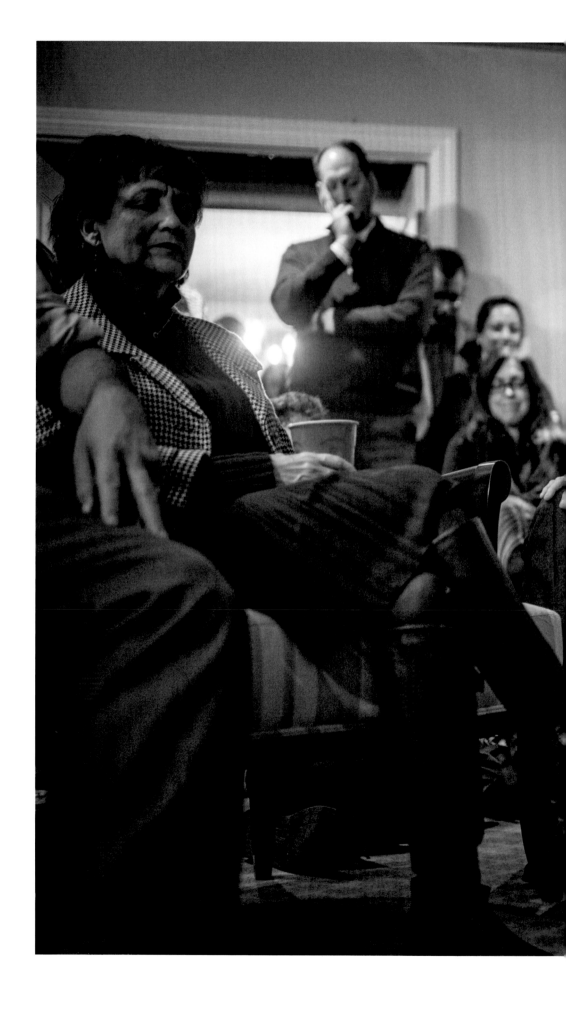

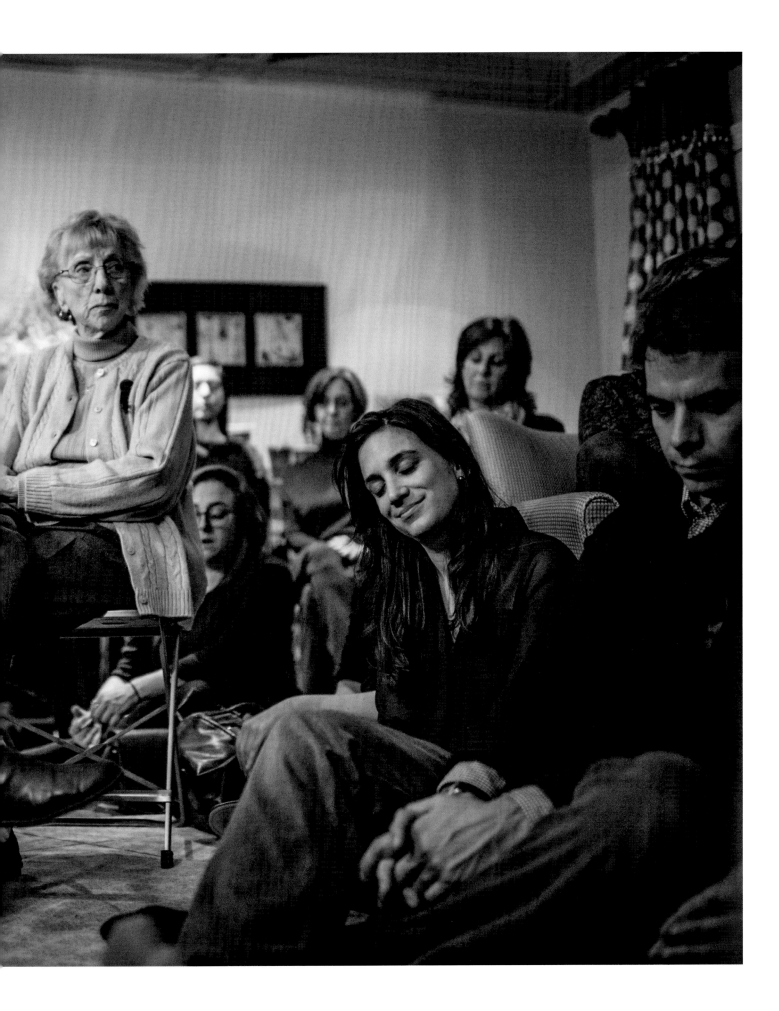

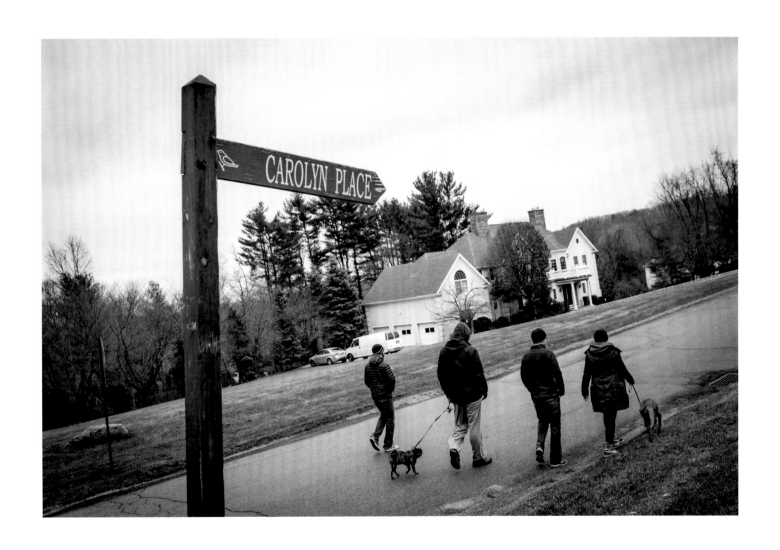

*Following the end of Shiva, the seven-day mourning period in Jewish tradition, one is supposed
to take a short walk around the block to symbolize their return to society. We leashed up the dogs and headed
out in the cold New York air. We were lucky—we had each other and so many who supported and
loved us, and we had our parents to thank for that. — Nancy*

I know that in the scheme of things my life is insignificant, but faced with the tangible reality of a life-threatening disease, I often wonder if I have served any purpose during my time here.

As a serious student my original plan was to be a lawyer and protect the rights of the most vulnerable.

The "motherhood/family" thing just sort of happened organically; and it was the most difficult and fun thing I have **ever** done! I put the best I have to offer into my children Jessica, Nancy and Matt. Maybe my purpose was to nurture these three, so that they will make powerful positive imprints on this world.

(I suppose all mothers think this way :))

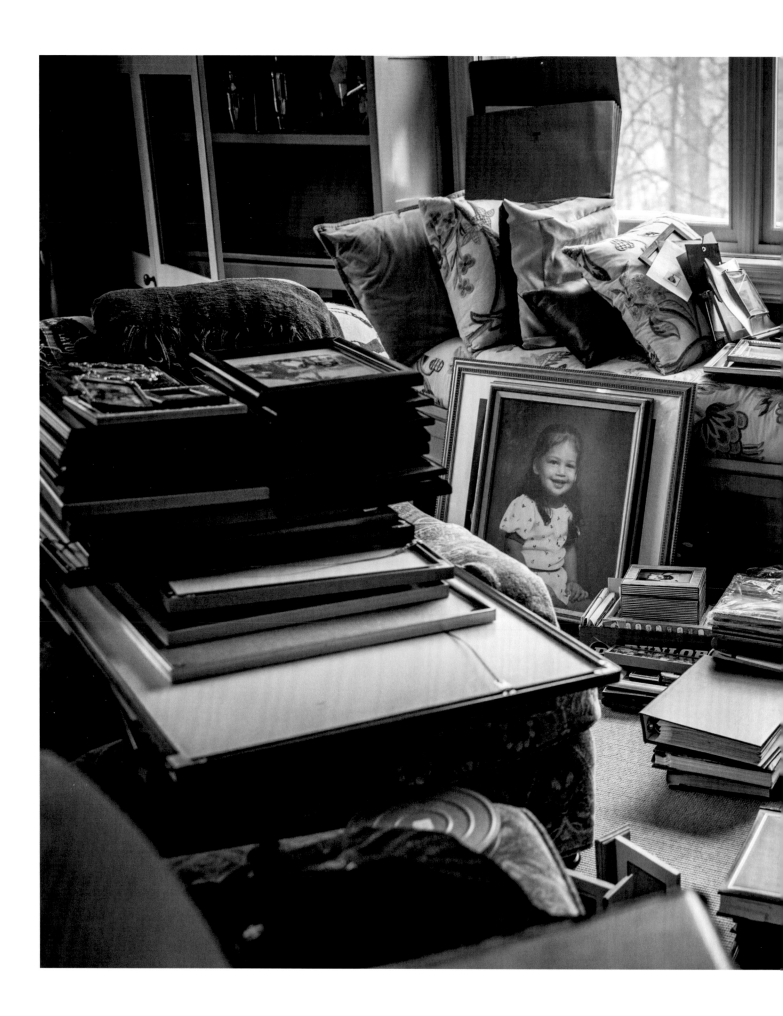

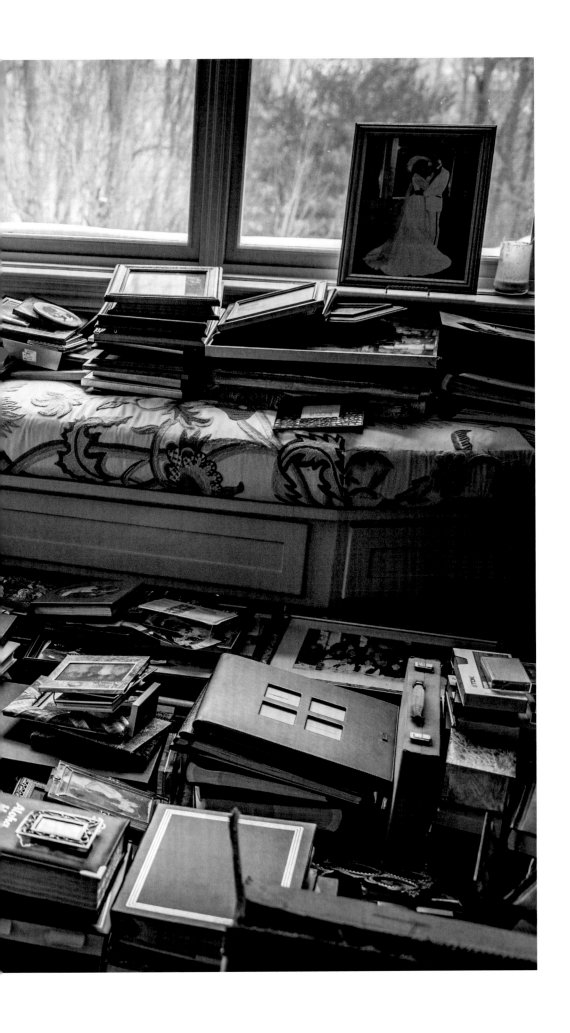

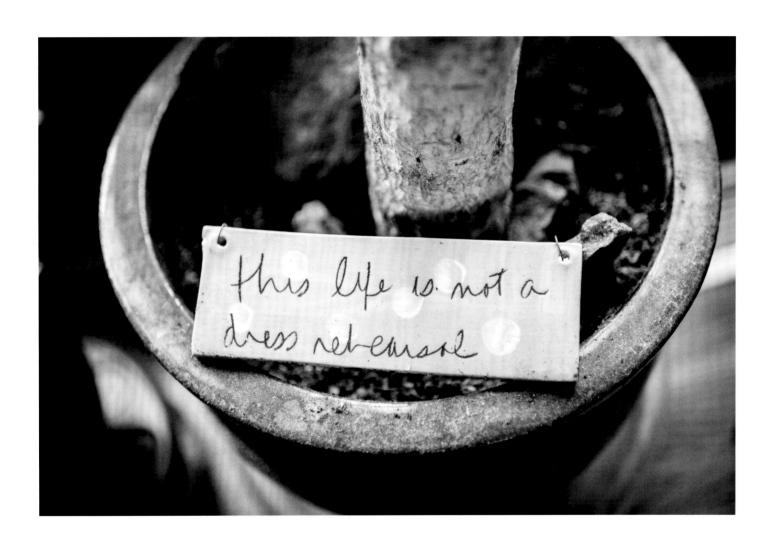

I saw her coming down the aisle—she was a vision.
An interesting thing happened when we were under the chuppah. I've always been a person who
just tries to soak up the scene and etch it in my memory, for posterity, because I live in
my memory. I remember at some point just looking up above the chuppah for a sign. I said:
"Just show me a sign that you're there," alluding to my parents, Gene and Rhoda. I actually
remember verbalizing that to myself. The next thing I knew, there were two yellowjacket wasps
that got under Mom's veil. It was scary! I was starting to poke them away and brush
them out, and then I realized, they weren't trying to sting Mom; they were trying to kiss her.
I really believed that that was the sign that I had just asked for. — Dad

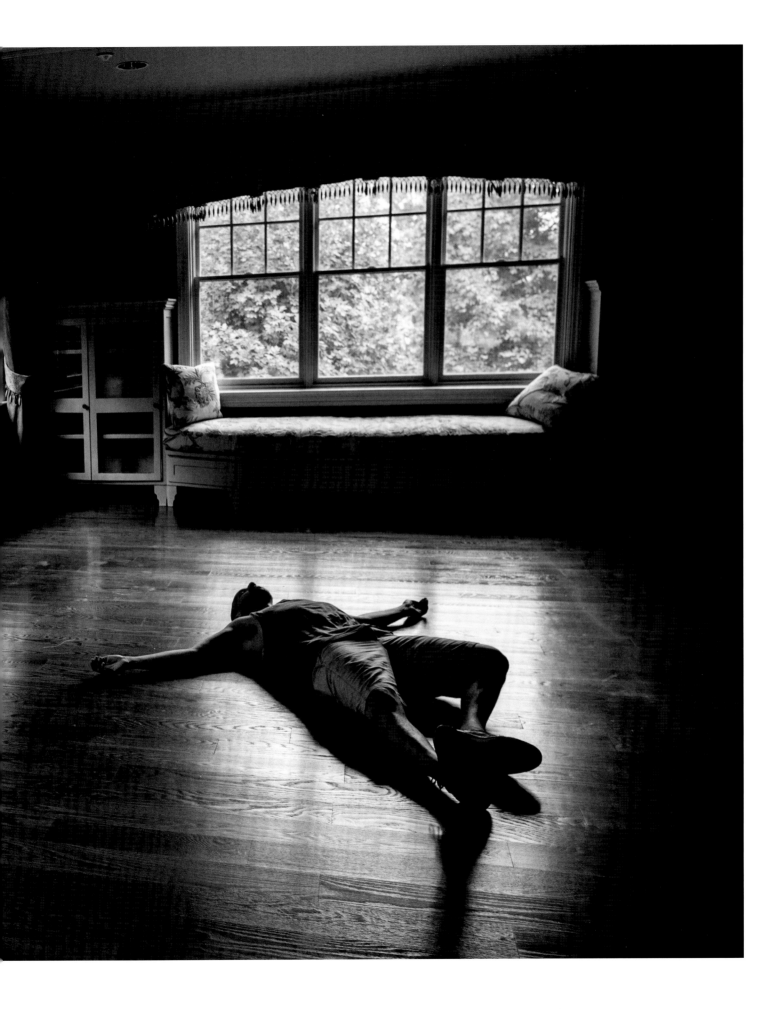

It was surprisingly easy for me to say goodbye to my childhood home. I'll admit that I am a
bit of a packrat, but it's because I am an extremely nostalgic person and I didn't think I was ready to
let everything go. Once the house was empty, there were no signs of who had been there and
the memories and experiences that had unfolded. It was no longer our home; it was just a house.
My room was a blank slate and a new family would move in and create their own memories;
perhaps have their own joy and sadness, just like we did. — Nancy

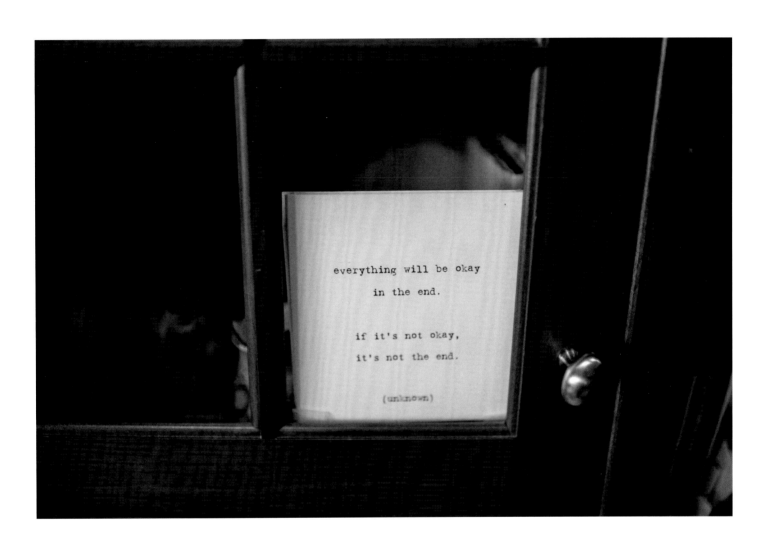

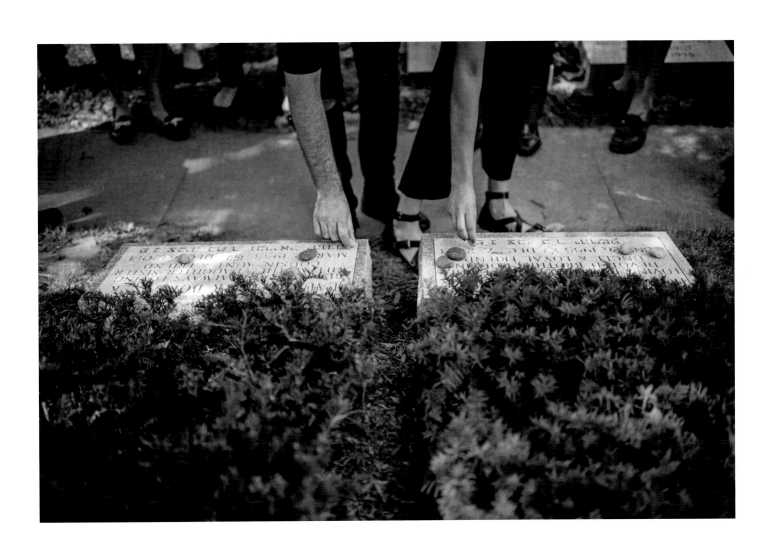

Courage isn't the absence of fear—it's knowing that you are afraid and doing it anyway. Don't spend your days avoiding risk being fearful. Act, live your life on your terms. Life is precious, spend it without regrets in your own precious voice. For my three angels: if you want to talk, or feel my love ... look up in the night sky. I am always watching over you. — Mom

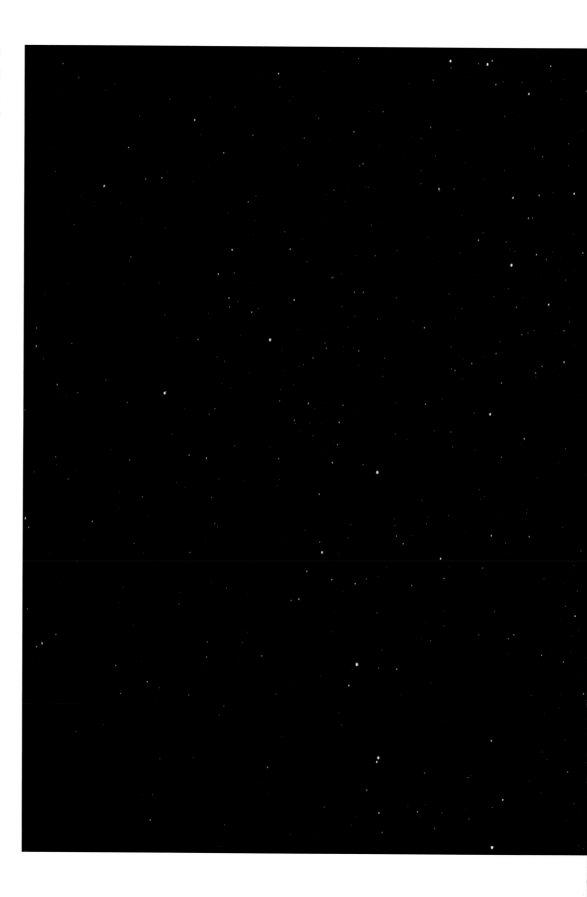

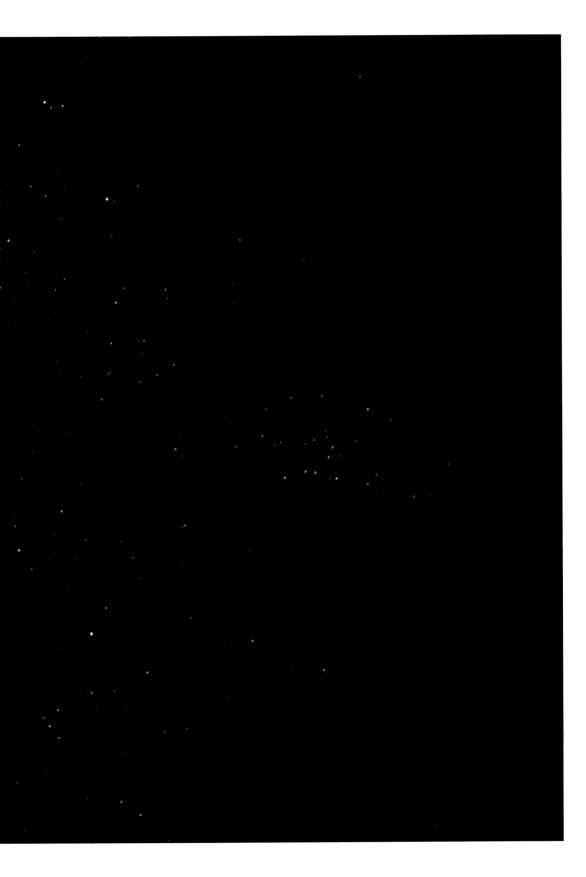

What I love about the night sky is that, whether it's a clear summer evening or a cloudy winter night, it will always be there, even if you can't see it well. — Nancy

Photograph by my brother, Matt Borowick

Acknowledgements

For the strangers who became friends, and the friends who became family: thank you for your openness, compassion, love, patience, encouragement, and guidance. To all of those who have shared your stories with me: it is because of you that I have never felt alone in this process. I will forever be grateful for your community.

Thank you to the International Center of Photography for their support as I began photographing Mom in 2009, and again in 2012, when Dad was also diagnosed with cancer. You helped me find balance in my role as both photographer and daughter and have been an important resource along the way.

Alison Morley: thank you for the tireless energy, thoughtful tenderness, and endless hours that you put into editing the photographs for this book, thus creating a narrative that makes it so special.

James Estrin: what a privilege it has been to work with you and get to know you over these past few years. You are a never-ending stream of encouragement, inspiration, and support. You have been instrumental in the development of this story, the life it took online and in the pages of *The New York Times*, and beyond. Your kindness and generosity have allowed me to grow as a photographer and as a human being.

Michael Winerip: you came into the fold of our family at a delicate time. Under these complicated circumstances, you conducted yourself with such professionalism, thoughtfulness and compassion, the way only a seasoned journalist could.

Frank Meo: although you have been my advisor for just these last few years, it feels like we have known each other forever. Thank you for your knowledge of the industry, genuine care for my family, and guidance.

Bonnie Briant: you are not only this book's designer, but also my friend. It has been such a gift to have you on my team, and I will always be grateful for your endless supply of patience.

Jess Earnshaw and Romina Hendlin: my fellow ICP ladies. Beyond all of the photography, video, and editing advice you gave me, you have been extremely important pieces in this larger puzzle, and I am so thankful to know you both.

Stephanie Sinclair: you and Bryan have become like family. That is one of the beautiful surprises that has come from this difficult time in our lives. Thank you for your friendship—and for Moses, obviously.

Rebecca Cooney: since I first sat across from you during the portfolio review at ICP, you believed in this project, and me. You took a chance on an unknown photographer and jumpstarted my career as a professional photojournalist. Thank you.

Judith Levitt: you gave me the strength and courage to keep shooting and show our story in the public realm. Thank you for your heart and your wisdom.

Mary Virginia Swanson: thank you for believing in this project and for your priceless advice. It is also because of you that I found my amazing agent, Joan Brookbank, who has intelligently, passionately, and strategically translated my hopes for this book into reality. Thank you, Joan, for your perseverance and expertise.

Jean Francois Leroy and the Visa pour l'Image team: thank you for taking a chance on a different kind of story, and for giving this work a voice and a home on the walls of your beautiful space in Perpignan.

Blair Smith: thank you for the years of friendship and support as I have developed the textual components for this book and project. Your understanding of the story has helped me articulate my experiences and put those feelings into writing, which isn't very easy for me.

Dr. Barry Boyd: I once asked you how you got up each day and went to work knowing that many of your patients might die and you replied: "The character of an individual is most evident when they have nothing left." This has always stuck with me, as I saw this in my parents, who you were treating. You knew my parents for almost two decades, having treated Mom for almost eighteen years, and Dad for his last one. We are forever grateful for your passion; for not just treating but looking and fighting for new developments and potential cures. Thank you for never making them feel like they were just a number on a chart.

Rabbi David Ingber and Rabbi Aaron Brusso: the kindness and generosity that you showed towards my family was unparalleled. Thank you for putting us at ease during this difficult time.

Family and relatives (this means you: Grandma Marion, Paul, Phoenix, Jeff, Karen, Risa, Tucker, Ali, Ido, Lauren, Jodi, Wayne, Brandon, Ari, Richie, Laurie, David, Jessica, Sarah, Pam, Teddy, Barbara, Mike, Bruce, Rachel, David, Minx, Reid, Barry, Rachel, Cookie, Mike, Jamie, and Paul): we never expected to go through something like this when we did, but that is life, and as Dad said, we were never promised longevity. Your strength and care for me, my siblings, and my parents is something we will never forget or take for granted. The letters, messages, matzo-ball soup deliveries; you helped us get through this difficult time with extra love and calories and we will always hold you in our hearts.

Jessie and Matt: this is my project, but it is our story. Thank you for allowing me to tell it in my own way and for supporting and trusting me. I hope that this book acts as a reference over the course of your lives, as I know it will for me. I love you both so much and am so lucky to have such a great sister and brother in my life.

Kyle: I probably don't thank you enough for all that you have meant to me during these ten years we have been together. You have supported me in all of my endeavors (even the crazy ones) and have helped me stay grounded and focused. How did I get so lucky?

This book was made possible thanks to many people, especially the 740 Kickstarter backers who saw the potential in what this book could be, many of whom I did not know before the campaign. Thank you to Haley Hamblin for your hard work producing and keeping up the social-media outreach, Carl Saytor for your beautiful reward, match and gallery prints, and Madeline Collins, for sifting through hours of audio, and transcribing the words of my parents.

Of those backers, all of whom I love, I wish to especially thank those who awed me with their generosity: Grandma Marion Turk, Matt Borowick, Mike Turk, Ted and Barbara Turk, the Kerchner family, Sarah Warden and Ryan O'Reilly, the Boren family, Jill Knight, Jeanie Lombardi, Lisa and Michael Lehman, Molly Gellert, Frank Meo, Stephanie Sinclair and Bryan Hoben, John Ewing, the Priester clan, Shin Woong-Jae, Diane McNulty, Nick and Jenna Arison, Allison Davis O'Keefe, Peter Timothy Metzler and Kathryn Elaine Rowedder, Howard and Mary Ellen Nusbaum, Steven Abramow, the Woltz family, the Cohen family, Amy and Frank Linde, Louis and AnnMarie Fusco, Anne and Michael Weprin, Dr. and Mrs. Douglas Rosen, the Jonap family, Linda and Steph Fogelson, Sheryl Grutman and Pamela Grutman, the Suskin Family, the Kelfer family, the Geller family, Barry and Beth Steinberg, Jacob Oresky, Joshua Fine, Nicholas Schoeder, Dr. Christiane Jenemann, Linda Ronis Kass, Melissa Kestel, Louis Nonouchi, Sophia Yeres, Fredrick Orkin, MD., Heike Maglaque, Ed Kasselman, Miriam Tejaswini Sayed, and B. and K. Yandell.

Found Family Objects

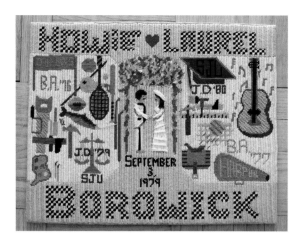

Dad loved to do needlepoint. He said that it was a way for him to relax and be creative. It was no surprise, however, since so many women raised him. This was a piece that he made around the time that he and Mom got married, perfectly including the important details about their lives together. His 1970s mustache is totally on-point.

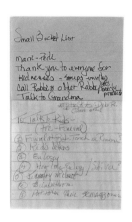

Mom was a list maker. I get that from her. These were just two of the many lists that we discovered while cleaning out our home. I love these because they remind me of how selfless and thoughtful she was. She always thought of others, even at the end of her life. I also appreciate the simplicity of her priorities, and how she made sure to include tasks that made her feel good about herself, like a manicure and pedicure (or a mani-pedi, as she would have said). Her disease robbed her of many of the characteristics that made her feel like a woman; these little luxuries made a big difference.

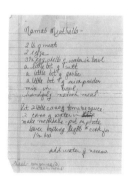

Mama, who was known best for her famed meat-balls, was his grand-mother, and one of the women who helped raise Dad when he was young, after both of his parents died of cancer. This dish became a staple in my family's home despite its obvious lack of flavor. Mom would occasionally put her own spin on the traditional recipe, but we often just wanted the bland, simple version we knew and loved.

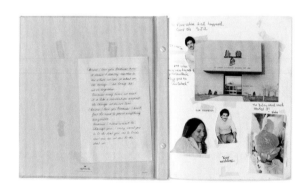

Nearing the end of her life, Mom shared with us a scrapbook that she made during her early courtship with Dad. It seems that we Borowicks carry a prevalent scrapbooking gene, so this was not surprising to see.

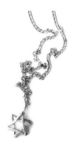

Mom kept everything. Some may call it hoarding, but I call it nostalgia. These are just four of the hundreds of letters that my parents wrote to each other over the course of their thirty-four years together. Mom saved them in boxes hidden within the depths of her closet. Reading them now, they help me to better understand the people that they were, and the lives that they lived, especially before their children came into the picture. It turns out that my parents had lives before we existed.

Dad wore this necklace pretty much every day of his life. After he died, it was nowhere to be found and it wasn't until after Mom died that it reappeared. We almost lost it because it was tucked away in the toe of one of his shoes, which was about to be put out for donation. He must have put it there for safe keeping before his final trip to the hospital. I will always picture it buried within his chest hair, reflecting the light around him.

These are the front and back covers of one of our oldest family albums, started in the 1970s. The pages are falling out, the tape has yellowed, and it's almost too fragile to move. Despite its tattered state, I treasure it, as it is jam-packed with memories of a full life well lived. I believe that Dad made this album and took thousands of photographs to make up for the absence of documentation of his own childhood.

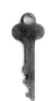

This key was found while cleaning out my parents' home shortly after they both passed away. It has no special markings or identifiers, and I am not entirely sure of to what it belongs. At this point, I will likely never know. In many ways, this reflected my larger experience; with the loss of my parents, I also experienced a loss of their stories and memories. This key represents an acceptance of the future, of moving forward and being faced with the unknown.

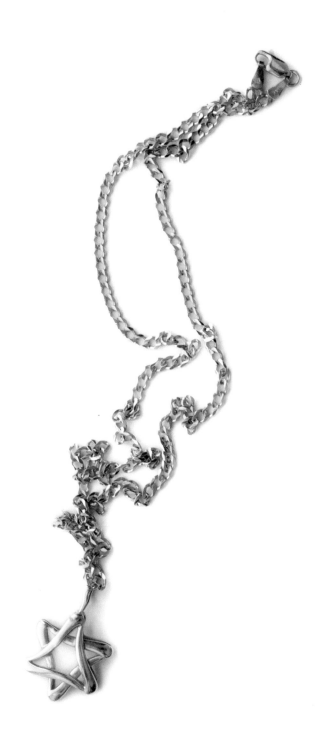